"Outside the Pale"

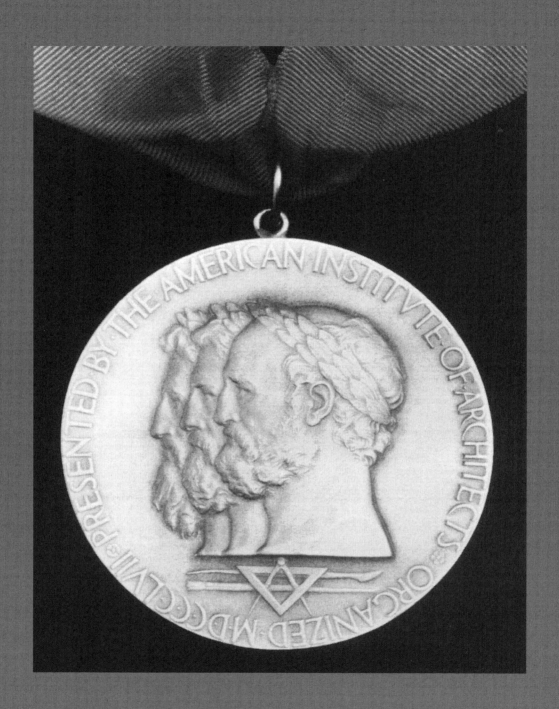

"Outside the Pale"

The Architecture of Fay Jones

DEPARTMENT OF
ARKANSAS HERITAGE

The University of Arkansas Press
Fayetteville 1999

Copyright © 1999 by Department of Arkansas Heritage

All rights reserved
Manufactured in the United States of America

18 17 16 15 14 5 4 3 2

Designed by Liz Lester

♾ The paper used in this publication meets the minimum requirements of the American National Standard for Permanence of Paper for Printed Library Materials Z39.48-1984.

Library of Congress Cataloging-in-Publication Data

Jones, Euine Fay, 1921–
 Outside the pale : the architecture of Fay Jones.
 p. cm.
 "Department of Arkansas Heritage."
 A catalog of an exhibit of the work of the architect Fay Jones at the Old State House Museum, Little Rock, Ark.
 ISBN 1-55728-543-8 (alk. paper)
 1. Jones, Euine Fay, 1921– —Exhibitions. 2. Organic architecture—Exhibitions. I. Arkansas. Dept. of Arkansas Heritage. II. Old State House Museum (Ark.) III. Title.
NA737.J64 A4 1999
720'.92—dc21 98-46529
 CIP

 Cover photograph © Thomas Harding.
 Frontispiece photograph courtesy The American Institute for Architects Library and Archives, Washington, D.C.

Acknowledgments

The project resulting in the *"Outside the Pale": The Architecture of Fay Jones* exhibit at the Old State House Museum in Little Rock began in 1994 as a collaborative effort of three agencies of the Department of Arkansas Heritage: the Arkansas Commemorative Commission, the Arkansas Historic Preservation Program, and the Arkansas Arts Council. The exhibit that this catalog accompanies is part of a three-pronged project that also involved a statewide survey of Jones-designed properties by the Arkansas Historic Preservation Program and the nomination of seven of those structures to the National Register of Historic Places, as well as in-state distribution of a version of the exhibit through the Arkansas Arts Council's Arts on Tour program.

Dozens of individuals and organizations have contributed to this project, including the following: Cathie Matthews, Jane Rogers, Bev Lindsey, and Barbara Heffington of the Department of Arkansas Heritage; Cathy Slater, Mark Christ, Helen Barry, Rusty Logan, Jeff Holder, Holly Hope, and Ken Story of the Arkansas Historic Preservation Program; Ronnie Nichols, Bill Gatewood, Gail Moore, Steve Gable, Jo Ellen Maack, Rita Cadwell, and Rob Marx of the Old State House Museum; the Arkansas Arts Council; the National Endowment for the Arts; the Arkansas Natural and Cultural Resources Council; the Arkansas Humanities Council; the American Institute of Architects and Tony Wrenn of the AIA Library and Archives; the Arkansas Museum of Natural Resources; the Art Institute of Chicago; Paul Beswick/Beswick International; H. Gordon Brooks II of the University of Southwestern Louisiana; Michael Dabrishus and the Special Collections Division, University of Arkansas Libraries,

Fayetteville; Don and Ellen Edmondson; Chuck and Margaret Ensminger; Liz Ensminger; Erffmeyer and Son/Esco; Edward Fields; the late Dr. Stephen Finch; Thomas Harding; Timothy Hursley; Robert Adams Ivy Jr.; SC Johnson Wax; Balthazar and Monica Korab; Ken McKnight; Prairie Multimedia; Oliver Radford; Gary Shepard; Mr. and Mrs. Breck Speed; Ezra Stoller/Esto; John Coghlan, Kevin Brock, Brian King, Liz Lester, and Beth Motherwell of the University of Arkansas Press; and the Frank Lloyd Wright Foundation. Our thanks also to contributors who became involved in the project after this catalog went to press.

Special thanks go to Maurice Jennings and David McKee of the Maurice Jennings + David McKee Architects firm, for offering their time and expertise and for loaning artifacts for this exhibit.

And above all, thanks go to Fay and Gus Jones for all of their assistance in every facet of this project.

This project is supported in part by grants from the National Endowment for the Arts, the Arkansas Humanities Council, and the National Endowment for the Humanities. This project is also supported in part with Real Estate Transfer Tax funds administered by the Arkansas Natural and Cultural Resources Council and with tax funds from the State of Arkansas. However, the contents and opinions do not necessarily reflect the views or policies of the Department of Arkansas Heritage or its agencies, nor does the mention of trade names or commercial products constitute endorsement or recommendation by the Department of Arkansas Heritage or its agencies.

The publication of this catalog was supported by funds from the Department of Arkansas Heritage.

Contents

Foreword
 by Robert Adams Ivy Jr. viii

"As early as I can remember, I liked to paint and draw, but I also liked to build things...." 2

"First, it's talking with the client in great detail...." 26

"You should feel the relationship, to the parts and to the whole." 48

Appendix 82

Foreword

Earth and Sky
The Architecture of Fay Jones, FAIA

ROBERT ADAMS IVY JR.

Fay Jones's architecture begins in order and ends in mystery. His buildings, which employ rock-solid materials arrayed with geometric precision, inevitably connect one specific place with natural laws and ultimately with larger, ineffable truths. His role can perhaps best be understood as mediator, a human consciousness that has arisen from the Arkansas soil and scoured the cosmos, then spoken through the voices of stone and wood, steel and glass. Art, philosophy, craft, and human aspiration coalesce in his masterworks, transformed from acts of will into harmonies: Jones lets space sing.

It is as if he has grasped a central duality at the heart of matter, a gap between the infinitely grand and the infinitely small, then reconciled those forces with his art. The work bears witness to the present moment, with its soaring spaces in which forest or mountain vista are interconnected with the smallest details. An interplay of opposites characterizes Jones's architecture, providing a tension and the opportunity for resolution. Open versus enclosed spaces, exteriors flowing into interiors, rational geometries versus sculptural ones, Cartesian clarity versus Jungian symbolism, compression versus tension, dark and light—the list is extensive and descriptive of his palette.

These twin motifs, earth and sky, are present in his

earliest work, including his own house, which counterpoises an airy, light-filled living floor above a shadowy grotto. Or in Stoneflower, a tiny weekend retreat that leaps up and out above an Arkansas lake from a womb-like, rocky base. The chapels and pavilions of his later years purify these motifs, reducing the issues to skeletal clarity. They remain his masterworks, signature expressions that vault Jones from the shadow of his mentor, Frank Lloyd Wright, into his own renown.

Wright looms large in Fay Jones's world. It was Wright who inspired young Jones to become an architect, who later took Jones under his wing and invited him to visit Taliesin. Jones's four months in the fellowship, where he worked on the Price Tower and on the Llewelleyn Wright house, confirmed Jones's status as a Wright disciple. He has never wavered from that devotion. Many of his forms, spaces, and details are unmistakably Wrightian: the memories of Taliesin run through his own house, often directly quoted, and in most subsequent designs.

Yet, as Jones asserts, "I've never tried to be a little Frank Lloyd Wright." Jones's own blend of education and experiences allowed him to build on Wright's ideas, refashioning them according to his own vision. One significant difference, Jones's evolving structural expressionism, can be traced to the Arkansan's formal education in engineering prior to architectural school.

In addition, Wright was not Jones's sole mentor. Jones may have the distinction of being the only architect to have worked directly for both Wright and Bruce Goff. It was under Goff's leadership at the University of Oklahoma, where Jones taught architecture under Goff's tutelage, that the younger man discovered the interrelationship of the arts. He soaked in Goff's musical evenings and relished the intellectual discussions that ranged across philosophy and art. In a sense, Goff unlocked Jones's unconscious.

Unlike Wright, Jones has been an avid student and teacher of architectural history, ranging freely throughout

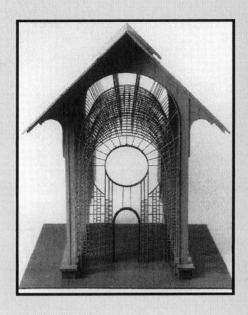

Model for Chapel for Chapman University, Orange, California. Fay Jones + Maurice Jennings Architects.

PHOTO BY JIM BAILEY/YB PHOTOGRAPHY STUDIO.

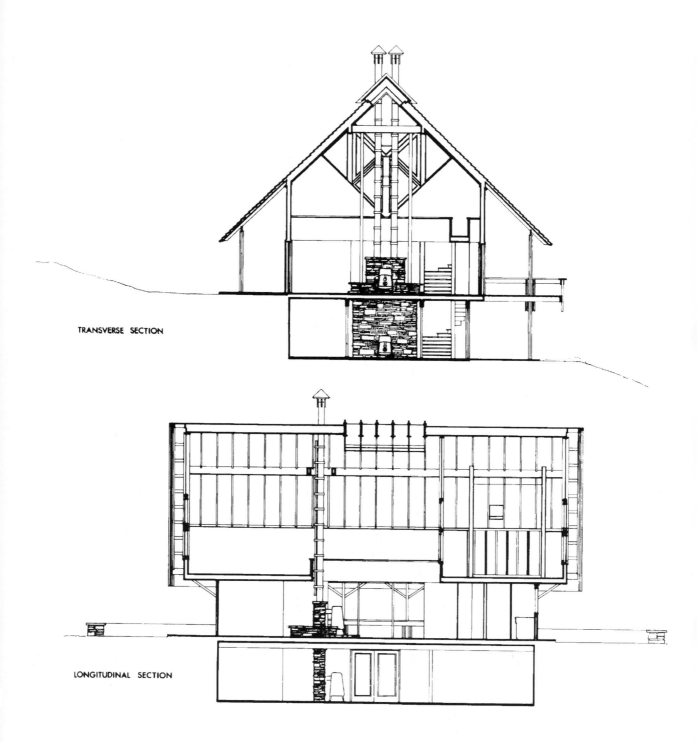

human endeavor and allowing its lessons to inform and inspire his art. Roman temples, Japanese pavilions, and Gothic chapels have all found direct references in Jones's hands.

Although he has consistently described himself as "outside the pale," Jones studied and admired modernist architecture. He mentions the work of Richard Neutra as being most influential, particularly Neutra's interest and skill in creating transparent boundaries between outside and in.

The notion of organic architecture connects all of the aforementioned architects, with Wright its most devoted advocate. This esoteric term, somewhat difficult to define, has its roots in the late-eighteenth and early-nineteenth-century Romantics like Blake, who glorified nature, and in philosophers like Schopenhaeur and Emerson, who found interconnections in nature at all scales. Jones has said, "Organic principles are not rules, they are really more aims and goals . . . (according to Mr. Wright) for a thing to be organic, it has to have a central kind of generating idea . . . and every part and piece has a part to play. Each then should benefit the other. There should be a family of form, a family of pattern . . . such as the whole is to the part as the part is to the whole."

In Wright's and Jones's understanding of organic architecture, no decision is more important than where a building rests in the landscape. Jones's houses, such as the Hall/Ensminger residence, typically follow Wright's dictate that a house should be not "on, but of a hill," a belief that results in houses often sited below the crown. Nature, according to Jones, accepts human intervention, responding well to idealizing. Thus it is permissible to dam streams to produce ponds of water and waterfalls, as he did at the Walton residence. "Ideally, you'd like to have it look like man and nature carefully arranged everything by mutual agreement, and each benefited immeasurably from the other."

LEFT, Reed house, Hogeye, Arkansas.
COURTESY OF SPECIAL COLLECTIONS DIVISION, UNIVERSITY OF ARKANSAS LIBRARIES, FAYETTEVILLE.

FOLLOWING PAGES, Pine Knoll, Little Rock, Arkansas.
COURTESY OF SPECIAL COLLECTIONS DIVISION, UNIVERSITY OF ARKANSAS LIBRARIES, FAYETTEVILLE.

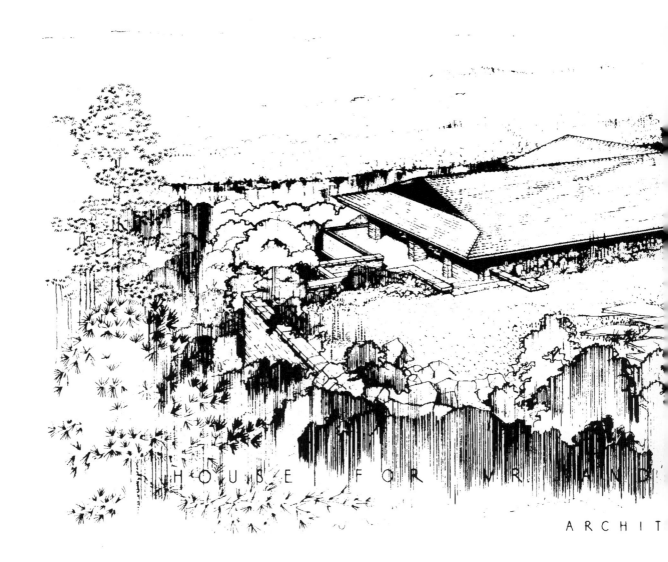

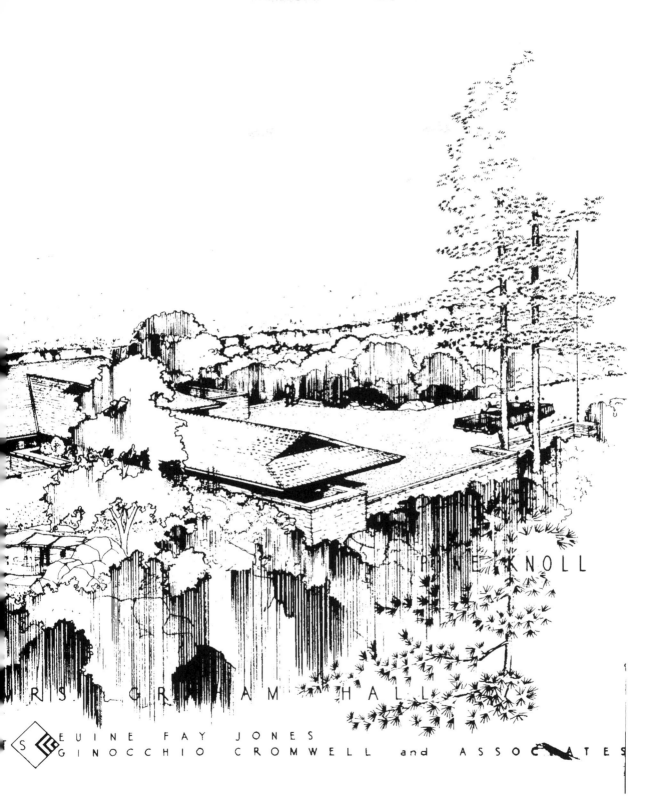

Light fixture trim, Fay Jones and Associates Architects.

PHOTO BY JIM BAILEY/YB PHOTOGRAPHY STUDIO.

Mathematical order creates the basis of structure, allowing sequencing of structure, of parts, and of places and spaces. These regular structural frameworks, adapted from geometric grids, relate human experience to time and space, grounding all of Jones's work in the here and now. Jones then often takes the structural system and knits it into an expressive device, adding layers of integrated ornament to space.

His primary building materials are simple: wood (often two-by members), stone, sheets of glass, primary steel members. Although the buildings appear highly crafted, few details require more than simple hand tools to accomplish. In fact, Jones took pride in developing simple details that ordinary carpenters could accomplish.

Light bathes interiors from clerestory windows, walls of glass, high windows, skylights. Mirrors capture the light, reflect and refract it back. No sources of artificial illumination remain exposed: all emanate from indirect sources, either from underneath built-in cabinetry, or up toward ceilings. Signatory chandeliers provide complex sculpture in entrance halls or above dining room tables.

Colors tend to be earth-toned, muted rusts and ochers, with occasional brighter accents in pillows and artwork. The architect pays attention to textures, providing rough, clawed concrete chimney pieces, smooth wood cabinets and floors, soft raw silk window hangings.

His attention is holistic, extending the organic eye from flowing spaces to furnishings to ashtrays. Indeed, these houses as works of whole craft are so complete that personal effects seem out of place. When new owners occupy a Jones house, there is always a moment's angst over the character of the new furnishings: will they fit with the overall aesthetic?

The accumulation of one individual's vision, so thoroughgoing in its detail, provides a distinct sensory experience, whether of spatial perception, of texture and touch, even of smell. Smoky hearths, damp walls with

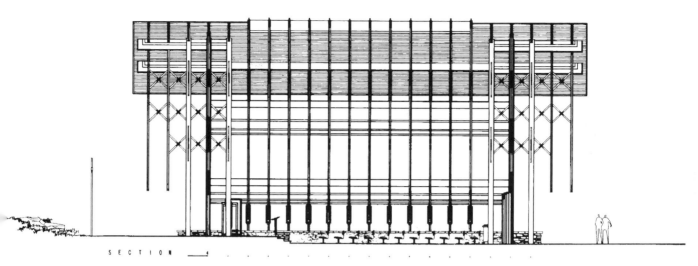

Thorncrown Chapel, Eureka Springs, Arkansas.

COURTESY OF SPECIAL COLLECTIONS DIVISION, UNIVERSITY OF ARKANSAS LIBRARIES, FAYETTEVILLE.

dripping water, spicy woods—they all bear a certain characteristic Jones tang, lacking in contemporary gypsumboard creations.

The sensory experiences are woven together through structure and space with a deliberate sequence: from entering the property to passing into a boudoir, the visitor finds modulated pathways to discovery, all informed by the architect's hand. Nothing, it seems, is left to chance.

For someone who chose to remain in Fayetteville, Arkansas, Fay Jones has achieved remarkable visibility and honor. Awarded the Gold Medal by the American Institute of Architects in 1990 for his body of work, Jones found himself deluged with potential commissions, most of which he had to refuse. Instead, he chose to keep his practice small, limiting his work to projects that he knew that he could do well. Custom houses, chapels, and pavilions continue to form the core of his firm's practice. Together with his partner Maurice Jennings, Jones has broadened his practice from Arkansas and the surrounding states to California, Massachusetts, Michigan, and South Carolina—literally from coast to coast.

Thorncrown Chapel in Eureka Springs, Arkansas, served as a springboard to national fame in 1980, followed by Cooper Chapel, Pinecote Pavilion, and others. The size of the houses he produced ranged from modest faculty members' houses of the 1960s to multimillion dollar, highly personalized residences that clients still seek. However, Jones's period of greatest maturity, characterized by those three public structures, has never been equaled.

Like his predecessors, Jones works outside of mainstream tastes (and lives outside of trend-setting urban centers) that represent contemporary society's constant quest for the fashionable. His place in history is unclear. What can be argued is that Fay Jones stands out as a follower of Frank Lloyd Wright who managed to carry the legacy of organic architecture forward to the end of the twentieth century, yet create his own, distinctive architecture. Certain works, like Thorncrown Chapel, have become touchstones of excellence, offering inspiration and a spiritual quality in a secular age.

Robert Adams Ivy Jr., FAIA, is editor in chief of *Architectural Record* magazine, a position he has held since late 1996. The native Mississippian is a graduate of the University of the South, where he majored in English, and Tulane University in New Orleans, where he received a degree in architecture. The author of the 1992 book *Fay Jones*, Ivy has been an architect with an active practice in the Mid-South, a critic for national publications, and a frequent spokesperson for his profession.

"Outside the Pale"

Discontinuous crossing connector, Thorncrown Chapel, Eureka Springs, Arkansas. Fay Jones and Associates Architects.

PHOTO BY JIM BAILEY/YB PHOTOGRAPHY STUDIO.

"As early as I can remember, I liked to paint and draw, but I also liked to build things...."

Fay Jones was born January 31, 1921, in Pine Bluff, Arkansas, to Euine Fay and Candy Louise (Alston) Jones. The family moved to Little Rock and then to El Dorado, where the elder Jones opened a restaurant.

"We moved to El Dorado in the 1920s, when it was somewhat of a boom town because oil had been discovered in the area. My parents had a restaurant there, so I grew up working in the restaurant. It made me realize that I didn't want to be in the restaurant business, so I was looking for another field all along."

"As early as I can remember, I liked to paint and draw, but I also liked to build things, so I ended up with quite a series of tree houses through grammar school and high school. I didn't see a connection between art and construction. Art seemed to be a very delicate thing, and construction was usually made out of salvage—boards out of old fences, a tumbled down shack, or fruit crates from behind the grocery store, pulling out nails and straightening them and everything."

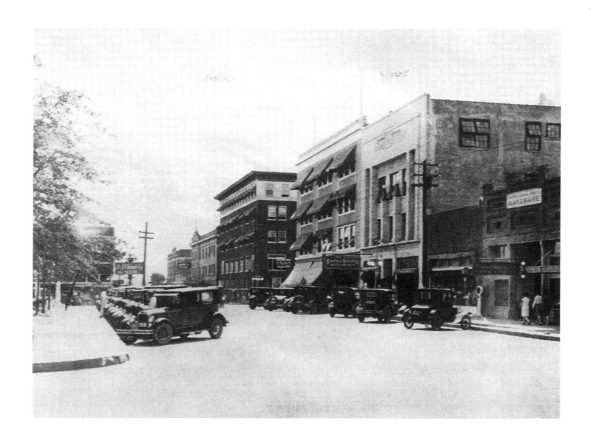

Downtown El Dorado, Arkansas, in the 1920s, including the Garrett Hotel, Masonic Temple, and Hanna-Himmins Hardware and Furniture Company.

COURTESY OF ARKANSAS MUSEUM OF NATURAL RESOURCES.

In 1938, the young Fay Jones saw a short film at the Rialto Theater in El Dorado on Frank Lloyd Wright's SC Johnson Wax headquarters in Racine, Wisconsin. The film inspired Jones to pursue a career in architecture.

"When I was a senior in high school, I went to the movie one day and there was this short subject called Popular Science. The subject of this particular film was this new building that was being built in Racine, Wisconsin, the Johnson Wax Building. I had never seen anything like it before except in Buck Rogers, or a Flash Gordon comic strip,

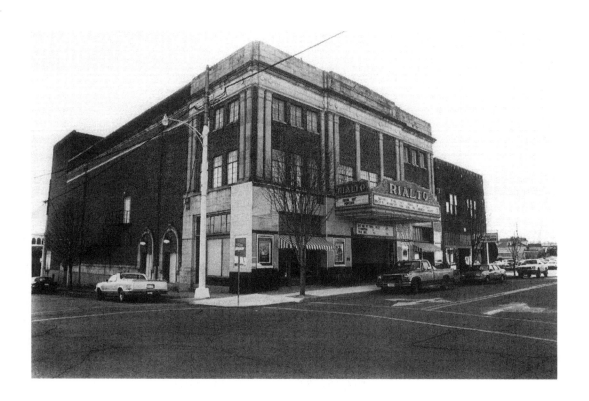

The Rialto Theater, El Dorado, Arkansas.

COURTESY OF EL DORADO NEWS-TIMES.

buildings of the twenty-first century. It was a building really being built, here and now, in the United States, and of course that was the first time I ever heard the name Frank Lloyd Wright. The film talked about the building not only in terms of unique construction, but about the aspect of the building as a work of art. So here it was, all coming together: a building can be an art form. I think it was one of those epiphany things. Suddenly I knew that it was a career in architecture I wanted to pursue. Architecture was not a totally new word to me; it just took on a new meaning that day, so I walked out of the theater knowing it's an architect I want to be."

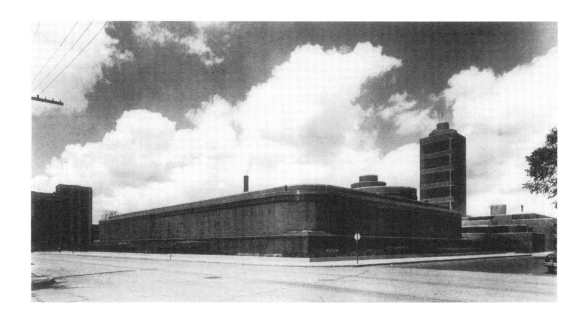

Exterior, SC Johnson Wax headquarters building, Racine, Wisconsin.

PHOTO COURTESY OF SC JOHNSON WAX.

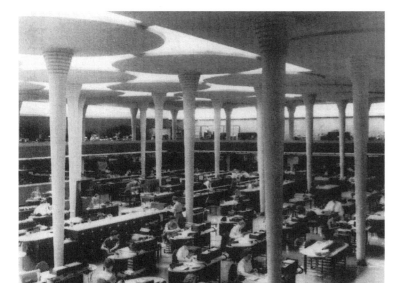

Interior, SC Johnson Wax headquarters building, Racine, Wisconsin.

PHOTO COURTESY OF SC JOHNSON WAX.

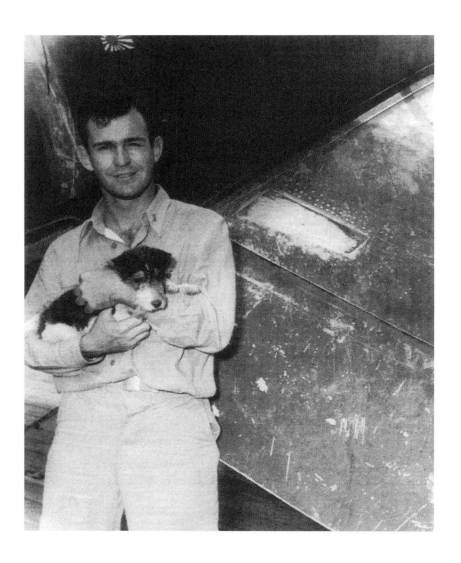

ABOVE AND FACING PAGE,
Fay Jones, USN.

COURTESY OF SPECIAL COLLECTIONS DIVISION, UNIVERSITY OF ARKANSAS LIBRARIES, FAYETTEVILLE.

"I graduated a short time later from high school, and the only place I could afford to go was the University of Arkansas. They only had two or three courses in architecture, so I studied civil engineering.

"I managed 2–3 years in the engineering program, but could see the world situation, where World War II was com-

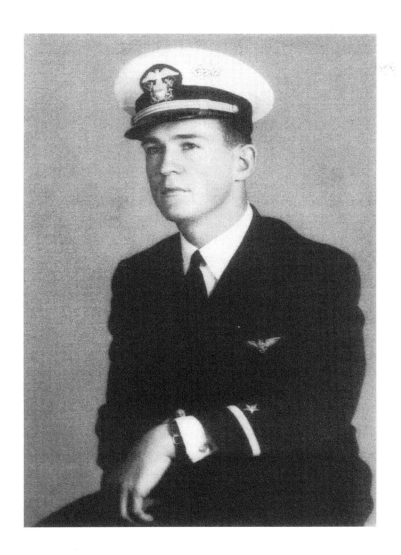

ing along, so I actually went into naval flight training before December 7."

"The naval experience was something that I was always very captivated by, the three dimensionality of flight, something here having to do with technical things, but there's also an aesthetic experience."

Gus and Fay Jones.

COURTESY OF SPECIAL COLLECTIONS DIVISION, UNIVERSITY OF ARKANSAS LIBRARIES, FAYETTEVILLE.

Jones married Mary Elizabeth (Gus) Knox on January 6, 1943, in San Francisco. The couple has two daughters, Janis and Cami.

"I met Mary Elizabeth, my wife, back just before going into the Navy. We had planned to get married at some later point, but I thought I was going to the Pacific when I ended up in San Francisco, so she came out and we were married in January 1943."

―――――――――――

Fay and Gus Jones in Rome, Italy, 1981.

COURTESY OF SPECIAL COLLECTIONS DIVISION, UNIVERSITY OF ARKANSAS LIBRARIES, FAYETTEVILLE.

Fay and Gus Jones in Monreale, Sicily.

COURTESY OF SPECIAL COLLECTIONS DIVISION, UNIVERSITY OF ARKANSAS LIBRARIES, FAYETTEVILLE.

Fay Jones's drafting tools.

PHOTO BY JIM BAILEY/YB PHOTOGRAPHY STUDIO.

Jones returned to the University of Arkansas in 1946, where a new program in architecture was starting. Edward Durell Stone designed the university's new fine arts building during this period.

"Edward Durell Stone from New York came down to design the fine arts building, and it was my first time for contact with a very important architect. He was a very charming individual, and he adopted our class in architecture; we called him a kind of 'godfather.' While he was not officially on the faculty, he spent a lot of time in the design studio. He acted as a design critic during those times."

Fay Jones and Edward Durell Stone.

COURTESY OF SPECIAL COLLECTIONS DIVISION, UNIVERSITY OF ARKANSAS LIBRARIES, FAYETTEVILLE.

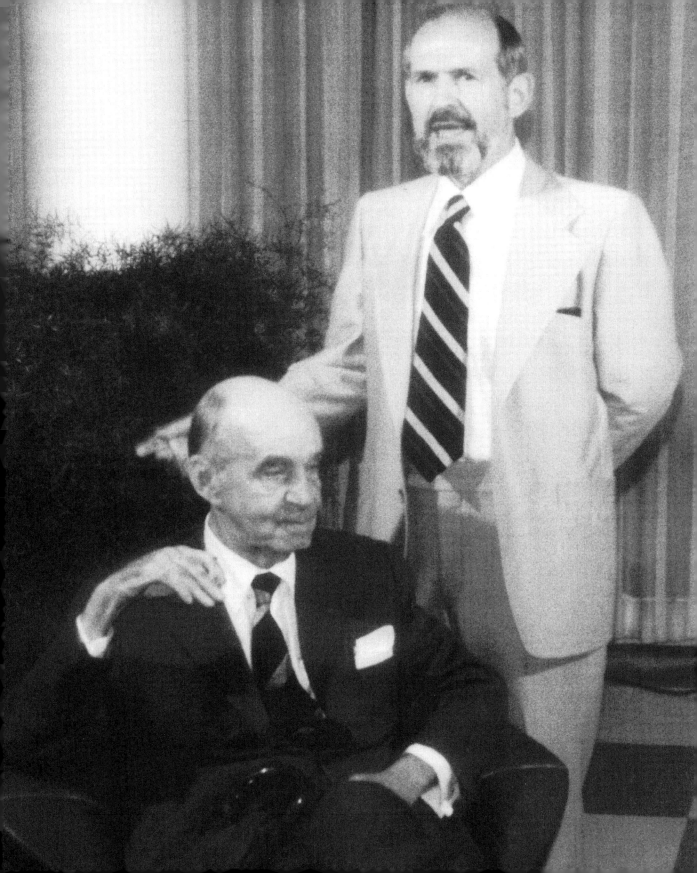

In 1949, Jones met Frank Lloyd Wright at the Shamrock Hotel in Houston, where Wright was to receive his American Institute of Architects Gold Medal.

"Four of us got up a little field trip, thinking of the possibility of catching a glimpse of our hero, Frank Lloyd Wright. This convention coincided with the opening of the Shamrock Hotel, which was quite an event in itself. When we walked into the lobby, it was filled with celebrities. A security guard appeared, so we thought we had better get out of a side entrance. We went down a side hallway, but at the end of the hall were these big padded doors with shamrocks on them. The doors parted and out walked Frank Lloyd Wright, putting on his porkpie hat and cape. We kids plastered ourselves back along the wall and gave him room to walk by, but I guess he saw our fright. He walked over, stuck out his hand, and said, 'Hi, I'm Frank Lloyd Wright,' and I said, 'Oh, I know,' and he said, 'I'm an architect,' and I said, 'Oh, Mr. Wright, we know who you are.'"

"By that time the national president of the AIA had followed him out in the hallway and said, 'Mr. Wright we want you to come back in here; there's a number of people you haven't met yet,' and he said, 'I've had enough of that party. This young man and I are going to see if this building has been built good.' For the next thirty minutes, I was kind of a prop, his Charlie McCarthy, as he explained some of the things about the building. He would point out a cutout in the ceiling and say, 'Young man, that's the effect of venereal disease on architecture.' We had gotten out in the lobby and I was shocked to see all of these movie stars in there. We walked on out there, and a certain movie star like Robert Mitchum would say to Robert Ryan, 'There's Frank Lloyd Wright!' Here were these stars pointing him out and I thought, 'My God, is architecture important or is it important!'"

Frank Lloyd Wright and Fay Jones, Fayetteville, Arkansas, 1958.

COURTESY OF SPECIAL COLLECTIONS DIVISION, UNIVERSITY OF ARKANSAS LIBRARIES, FAYETTEVILLE.

Jones accepted a graduate teaching fellowship at Rice University in Houston, Texas, from 1949 to 1951. He taught architecture at the University of Oklahoma from 1951 to 1953.

"*During the years I was in architecture school (1946-1951), there had been quite a radical change in architectural schooling in this country, converting from the Beaux Arts system before World War II, into modernism and the international style. The people who were really in the fore based their work on the concepts of Gropius and Le Corbusier but somehow, I guess because of the early impact Frank Lloyd Wright had on my work, I stayed fascinated with his work. But even though Frank Lloyd Wright has been the strongest influence on the work I've done, I've never tried to shield myself from other philosophical positions and ideas, especially those ideas that inform and inspire.*

"*When I was in graduate school at Rice University in Houston, I made a trip back to Fayetteville. I had seen publications showing the work of Bruce Goff, and I was fascinated by the kind of work he was doing, so I decided that on my way back to Houston I would go back by way of Norman, Oklahoma, and meet with him. He was a very generous man; we talked for a couple of hours. He showed me things he was working on at present and several projects he had done. . . . During the summer after I finished school, I was working in an architectural firm and I got a telegram from Bruce Goff offering me a job.*"

"*Being in close contact with Bruce Goff for a couple of years really opened my eyes to so many things, especially intangible things that architecture is so involved with. He could talk about rhythm in architecture, scale, and proportion, things that you could build on. He could talk about space and light and form in ways that seemed to be a coming together of these ideas. I feel that he has been a very strong*

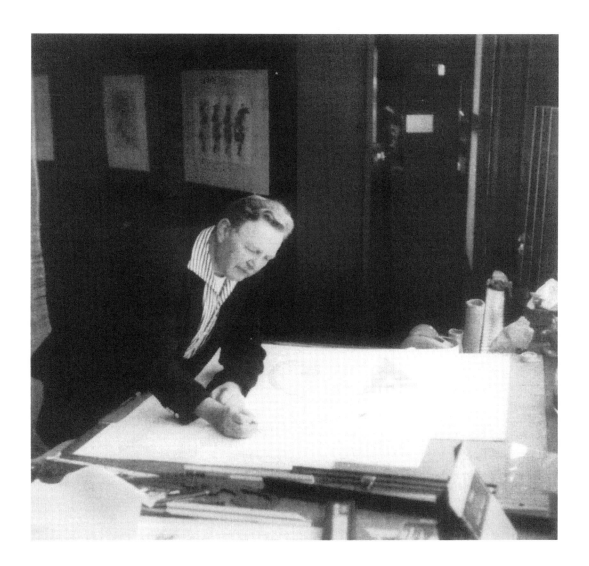

influence on my work over the years, but I have tried, just as in Wright's work, not to be a copyist but to reference the principles, the thoughts, and ideas that underlie his architectural composition. In fact I have often said that I have learned as much from Goff as I did from Frank Lloyd Wright. . . ."

Bruce Goff at the drafting table, circa 1951.

COURTESY OF THE ART INSTITUTE OF CHICAGO.

In 1953, Jones and his family spent a summer internship at Frank Lloyd Wright's Taliesin East at Spring Green, Wisconsin.

"Another thing I have to be grateful to Bruce Goff for is that when he had Frank Lloyd Wright come to the University of Oklahoma to give a lecture, Bruce had five or six faculty members take him out to dinner. During the course of the meal I was explaining to Mr. Wright how much I had admired his work over the years, and how I had hoped I would be able to study under him or be an apprentice at Taliesin. He said, 'What are you doing this summer? Bring your wife and two daughters and join up with us for the summer.'

"Early in the summer of 1953, we packed our things and headed for Taliesin. As it turned out, we were expected by Mr. Wright, but we weren't expected by Mrs. Wright; Mr. Wright had failed to tell her he had invited these Joneses to spend three months, so she was not quite sure what quarters we were going to live in and was a bit upset at Mr. Wright. She said that sometimes Mr. Wright did some reckless things."

"Taliesin was very strictly a working fellowship. Everyone had multiple things to do, and everybody tried to be as self-sufficient as possible. Not everybody there was there to be an architect, in fact very few were. They were concerned with the general philosophy of the place. There were people working in the gardens, doing pottery, weaving, or various other kinds of art. People graded roads and worked on various building projects, as well as doing work in the drafting room. It was a very exciting and stimulating kind of atmosphere.

"A couple of times a week we'd have a session with Mr. Wright, and we'd go over our drawings, reviewing what had been done and having him be a critic and make changes. What a wonderful experience: never once did he get upset or raise his voice, nor did he show any kind of temper. He had a sense of humor and was a very charming person. I knew

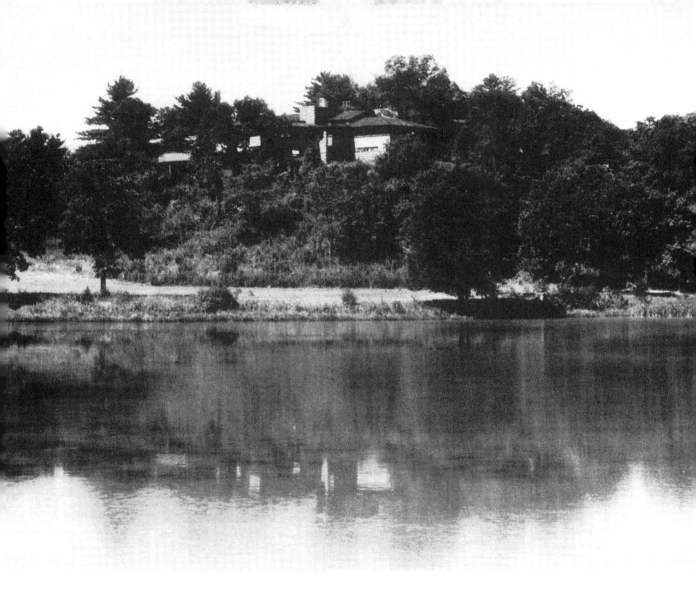

him the last ten years of his life and never once when I was around him did he raise his voice or show any kind of display of arrogance."

Taliesin East, Spring Green, Wisconsin.

PHOTO BY OBMA. COURTESY OF THE FRANK LLOYD WRIGHT ARCHIVES, SCOTTSDALE, ARIZONA.

Fay Jones, University of Arkansas, Fayetteville.

COURTESY OF SPECIAL COLLECTIONS DIVISION, UNIVERSITY OF ARKANSAS LIBRARIES, FAYETTEVILLE.

Jones began teaching at the University of Arkansas in the fall of 1953. He served as chairman of the Department of Architecture from 1966 to 1974 and dean of the School of Architecture from 1974 to 1976. He became professor emeritus in 1988.

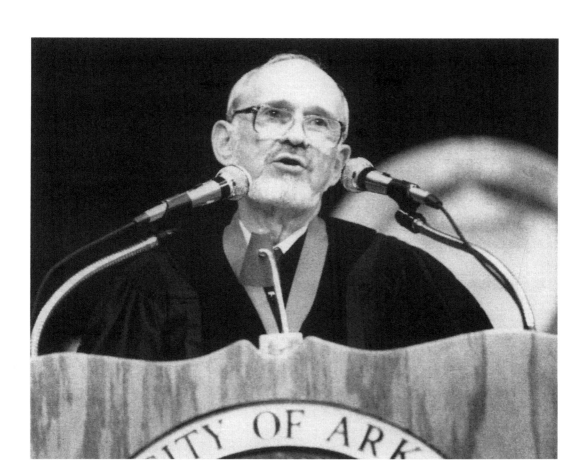

Fay Jones receiving an honorary doctorate in Arts and Humane Letters, University of Arkansas, 1990.

COURTESY OF SPECIAL COLLECTIONS DIVISION, UNIVERSITY OF ARKANSAS LIBRARIES, FAYETTEVILLE.

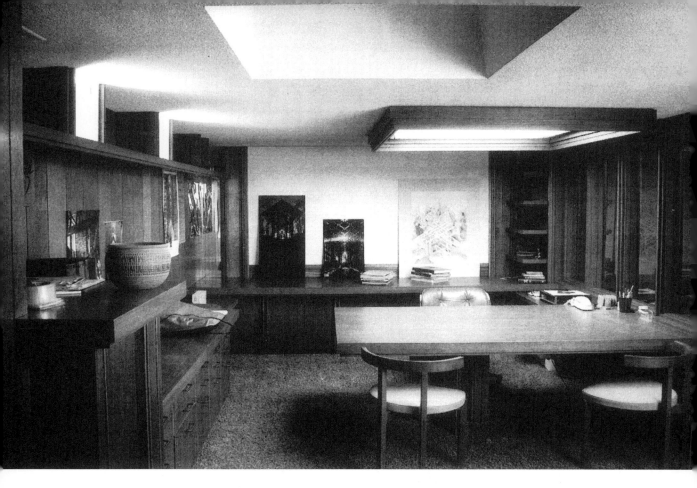

Fay Jones office,
Underwood Building,
Fayetteville, Arkansas.

PHOTO BY JIM BAILEY/YB
PHOTOGRAPHY STUDIO.

After returning to Fayetteville, Jones also enjoyed a thriving private practice. The firm has evolved from Euine Fay Jones Architect from 1953 to 1977, to Fay Jones and Associates from 1977 to 1986, and to Fay Jones + Maurice Jennings Architects from 1986 to 1997. Jones retired in late 1997, and the firm continues as Maurice Jennings + David McKee Architects.

"Maurice Jennings was a student of mine; he was in his third year when we first got to know each other. When he graduated in 1973, he came into the studio and has been here ever since; it has been over twenty years. Because he worked his way up to being such a valuable person in the studio in 1986, we changed the name to Fay Jones + Maurice Jennings. I can't think of life without Maurice."

FROM LEFT, Maurice Jennings, David McKee, Fay Jones, Leroy Scharfenberg, and Daryl Rantis.

COURTESY OF SPECIAL COLLECTIONS DIVISION, UNIVERSITY OF ARKANSAS LIBRARIES, FAYETTEVILLE.

FROM LEFT, Jason Hayes, Bradley Edwards, Maurice Jennings, and David McKee.

COURTESY OF SPECIAL COLLECTIONS DIVISION, UNIVERSITY OF ARKANSAS LIBRARIES, FAYETTEVILLE.

Light grate, Chapel of the Apostles, University of the South, Sewanee, Tennessee. Maurice Jennings + David McKee Architects.

PHOTO BY JIM BAILEY/YB PHOTOGRAPHY STUDIO.

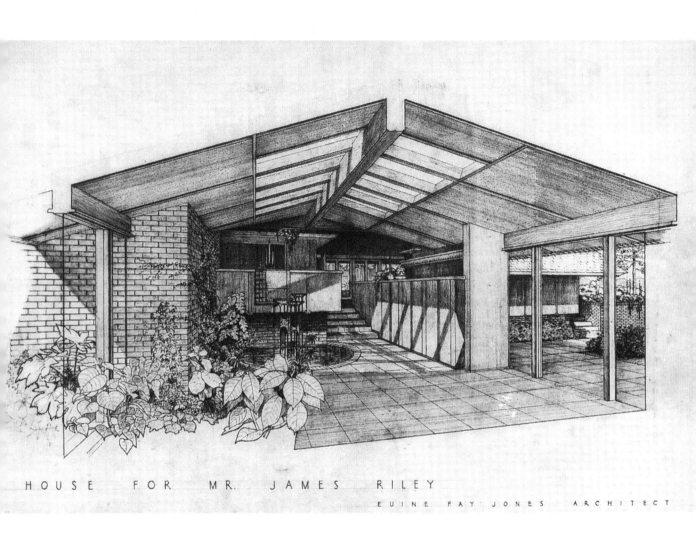

Drawing of House for
Mr. James Riley.
Fay Jones Architect.

COURTESY OF SPECIAL
COLLECTIONS DIVISION,
UNIVERSITY OF ARKANSAS
LIBRARIES, FAYETTEVILLE.

THE AMERICAN INSTITUTE OF ARCHITECTS

IS PRIVILEGED TO CONFER

THE 1990 GOLD MEDAL

ON

FAY JONES, FAIA,

WHO, FOR MORE THAN
FOUR DECADES, HAS CREATED
AN EXQUISITE ARCHITECTURE OF
GENTLE BEAUTY AND QUIET DIGNITY
THAT CELEBRATES THE LAND AND EMBRACES
THE AMERICAN SPIRIT. COMPLEX YET DELICATE,
GRAND IN VISION YET HUMAN IN SCALE, BOUND
FIRMLY TO THE EARTH YET SOARINGLY SPIRITUAL,
HIS WORK STRIKES AN EMOTIONAL CHORD THAT
TOUCHES THE SOUL OF ALL WHO ENCOUNTER IT.
HUMBLE, ORIGINAL, INTELLIGENT, AND
UNCOMPROMISING, HE EMBODIES
EVERYTHING THAT ARCHITECTURE
CAN AND SHOULD BE.

PRESIDENT

FEBRUARY 1990

AIA Gold Medal citation for Fay Jones, FAIA.

COURTESY OF SPECIAL COLLECTIONS DIVISION, UNIVERSITY OF ARKANSAS LIBRARIES, FAYETTEVILLE. PHOTO BY JIM BAILEY/YB PHOTOGRAPHY STUDIO.

Fay Jones received the highest honor awarded by the American Institute of Architects in 1990: the Gold Medal.

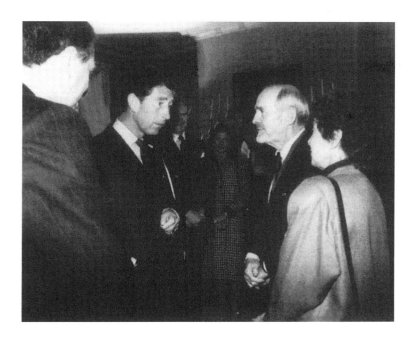

Prince Charles of Great Britain meets with Fay and Gus Jones after the AIA Gold Medal ceremony in 1990.

COURTESY OF SPECIAL COLLECTIONS DIVISION, UNIVERSITY OF ARKANSAS LIBRARIES, FAYETTEVILLE.

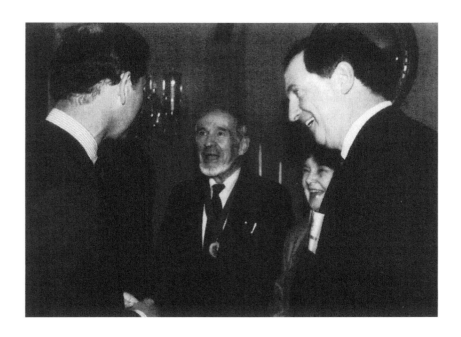

"First, it's talking with the client in great detail...."

"First, it's talking with the client in great detail, why they want to build, and why do they want to build here? Then it's analyzing winds, the pathway of the sun, features of the site—whether there is a stream or a view, a boulder or an outcropping—and then it's working schematically to make functional arrangements of the spaces they want."

"I have never thought that each project has to be an unusual house, a different house. I think each site is going to be different enough, owners are going to be different enough, their desires, their patterns of living are going to be different enough that if you solve problems as they are presented by the project, then it's going to turn out to be different from any other house."

Stoneflower,
Eden Isle, Arkansas.

© BALTHAZAR KORAB, LTD.

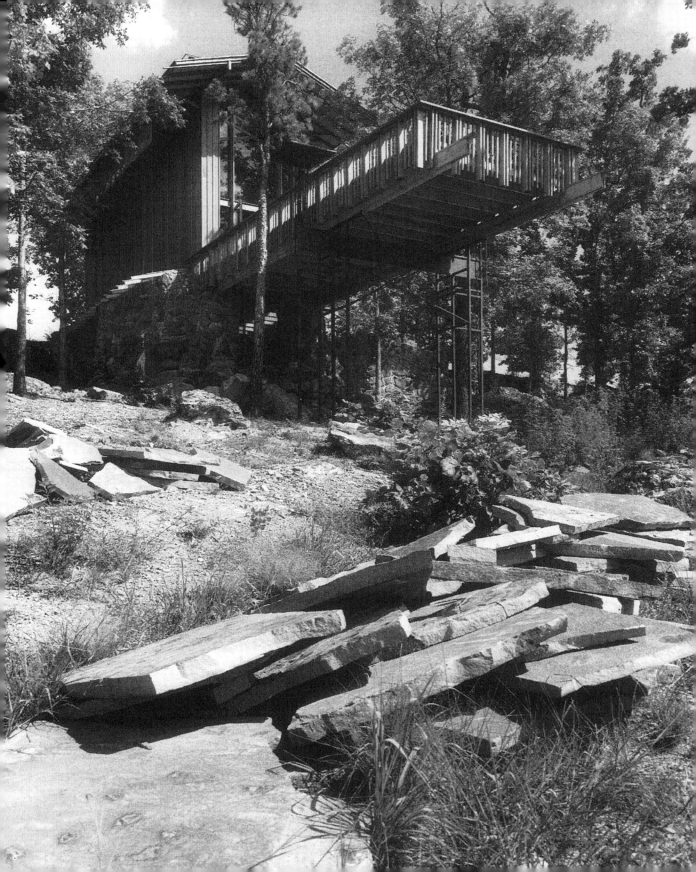

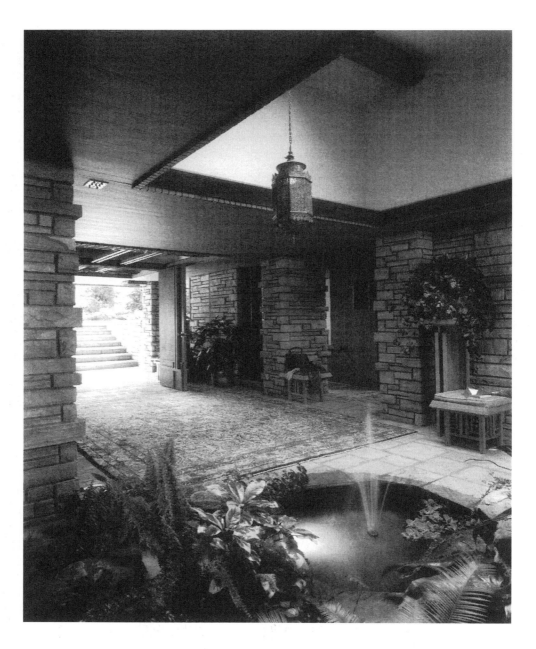

Pine Knoll,
Little Rock, Arkansas.
EZRA STOLLER © ESTO.

"First, it's talking with the client...."

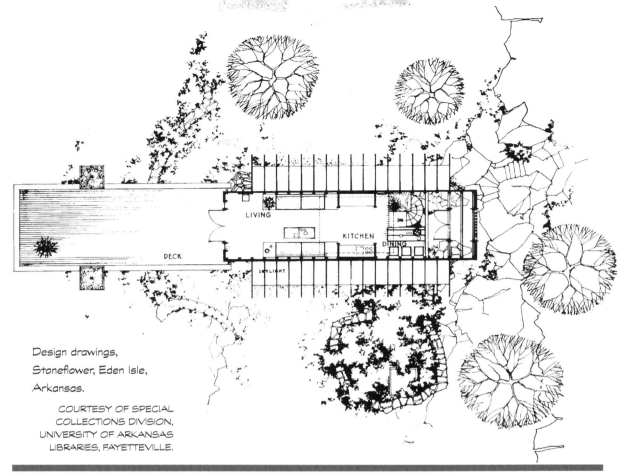

Design drawings, Stoneflower, Eden Isle, Arkansas.

COURTESY OF SPECIAL COLLECTIONS DIVISION, UNIVERSITY OF ARKANSAS LIBRARIES, FAYETTEVILLE.

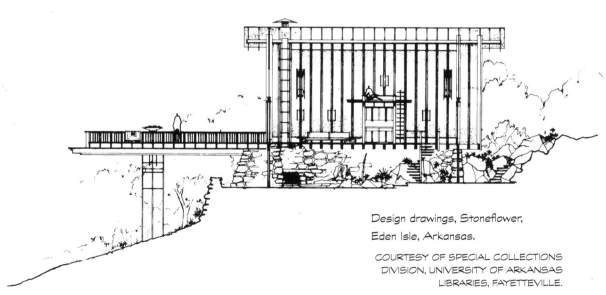

Design drawings, Stoneflower, Eden Isle, Arkansas.

COURTESY OF SPECIAL COLLECTIONS DIVISION, UNIVERSITY OF ARKANSAS LIBRARIES, FAYETTEVILLE.

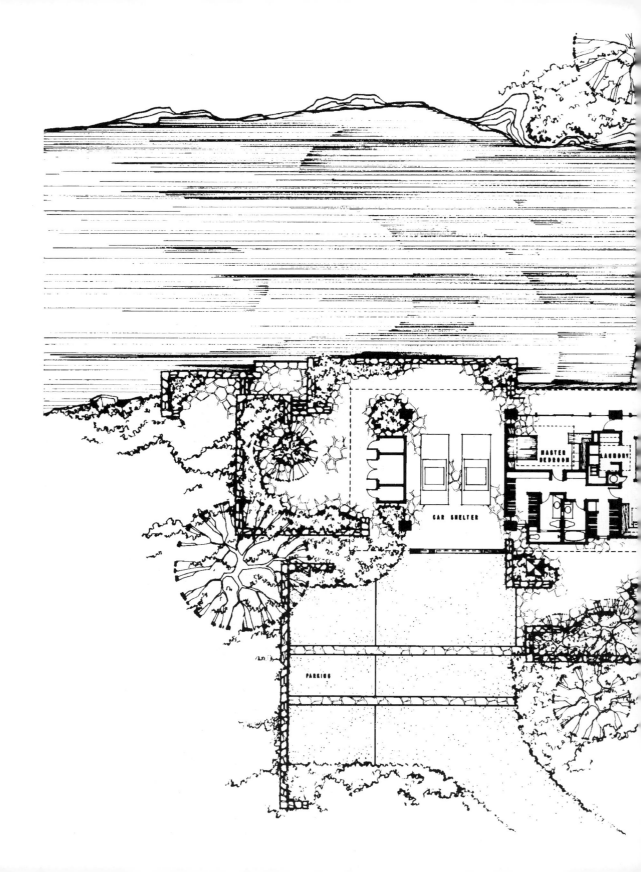

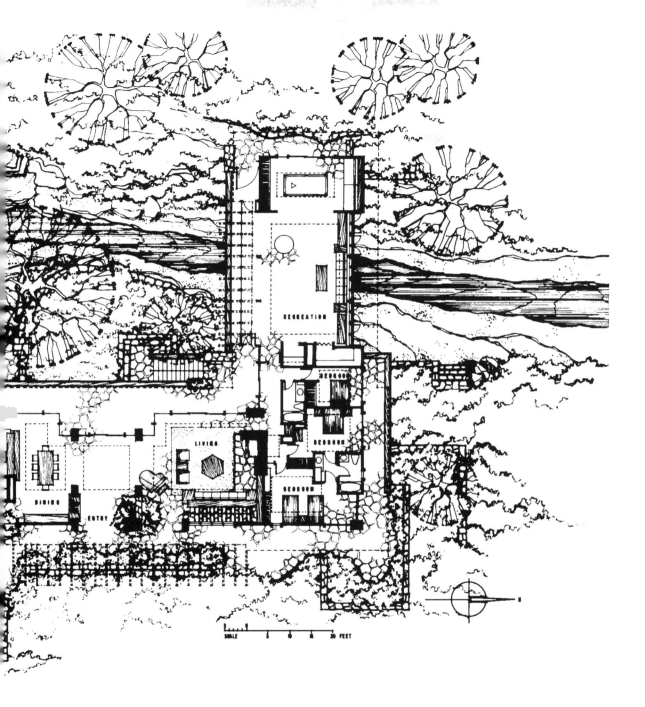

Private residence, Northwest Arkansas.

COURTESY OF SPECIAL COLLECTIONS
DIVISION, UNIVERSITY OF ARKANSAS
LIBRARIES, FAYETTEVILLE.

Bowl, Edmondson residence,
Forrest City, Arkansas.
Fay Jones and Associates.

PHOTO BY JIM BAILEY/YB
PHOTOGRAPHY STUDIO.

"To me it's more like nature's process of having a seed or kernel or nucleus, and then letting that manifest itself as the design grows to where you feel it's an organic part of that idea. It's a very opposite approach to design than the kind done by assembling parts from out there in the marketplace, the beautiful lamp, the beautiful sofa, the beautiful rug. It's from out there inward, in an assembly way, rather than from the inside out, in a growth manifestation, where you're trying to have every part and every piece reinforce the basic idea, and lend completion to the whole."

Plate, Edmondson residence,
Forrest City, Arkansas.
Fay Jones and Associates.

PHOTO BY JIM BAILEY/YB
PHOTOGRAPHY STUDIO.

Grill cover, Pine Knoll,
Little Rock, Arkansas.
EZRA STOLLER © ESTO.

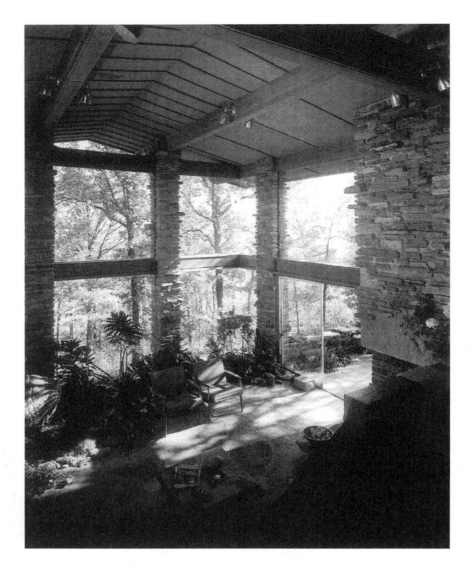

ABOVE, J. M. Clark residence, Arkansas.

EZRA STOLLER © ESTO.

RIGHT, Raheen, Fayetteville vicinity, Arkansas.

© PAUL G. BESWICK/ BESWICK INTERNATIONAL.

"Every man should have a place where he can have communion with himself and his surroundings, a personal environment free from disharmony and frustrations, a place to nurture his ideals and aspirations. That place should be his home, and if it transcends mere building and becomes a work of art, it is architecture."

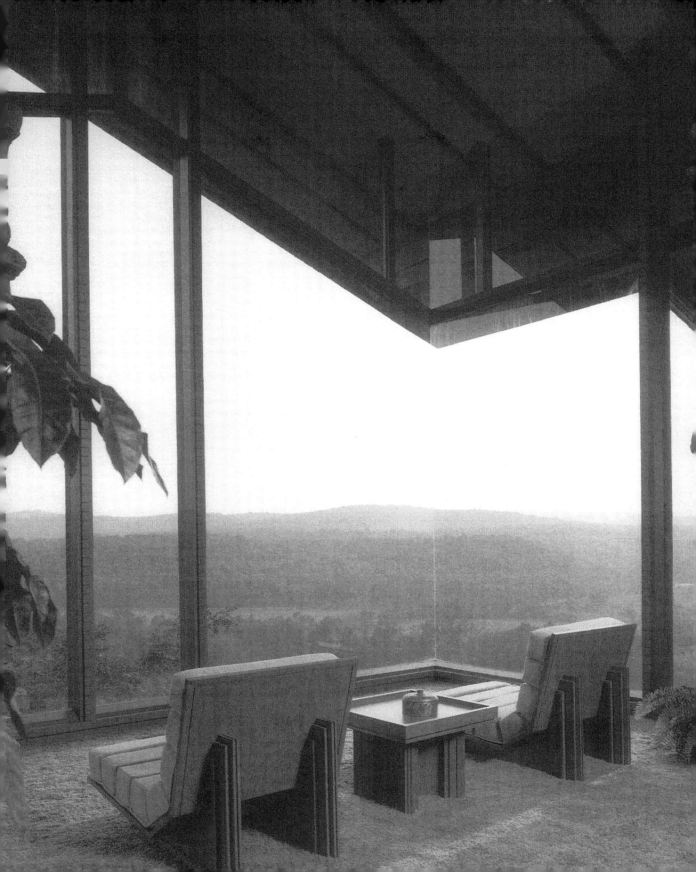

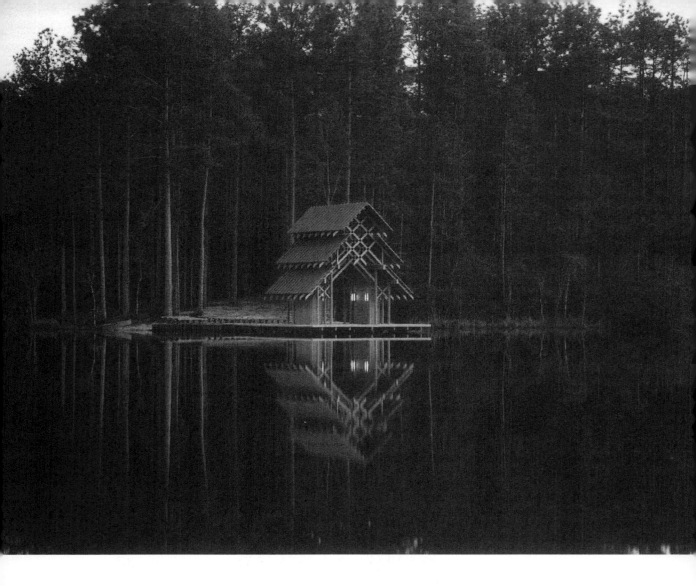

Pine Eagle,
Wiggins, Mississippi.

© TIMOTHY HURSLEY.

"... the owners of these [buildings] have generally been people of simple taste and gentle manners."

"... these buildings were not made to be fashionable or to win prizes, but really, only to please those who would use them ... and to belong to the places where they're built. I would like the work to be perceived as buildings with style, not of a style."

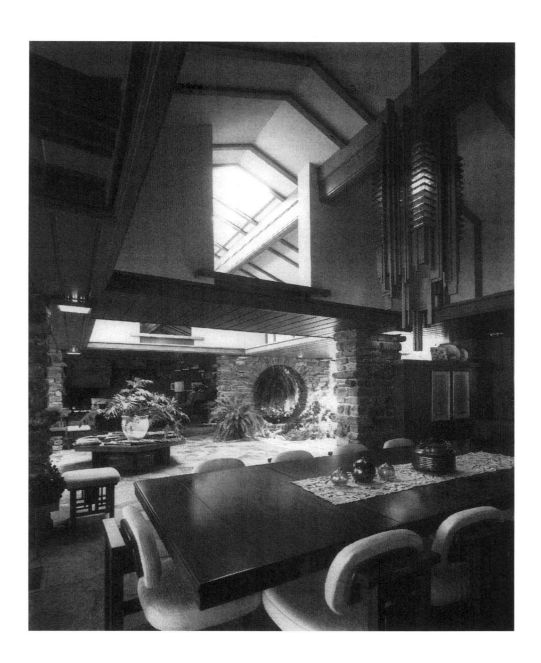

Private residence,
Northwest Arkansas.
© TIMOTHY HURSLEY.

". . . these small buildings express somewhat personal, at times romantic notions about shelter, and patterns of humane living. For me, their worth is mainly in their attempts to express a long-lasting desire for some better accommodations for our lives through architecture."

Stoneflower,
Eden Isle, Arkansas.

© BALTHAZAR KORAB, LTD.

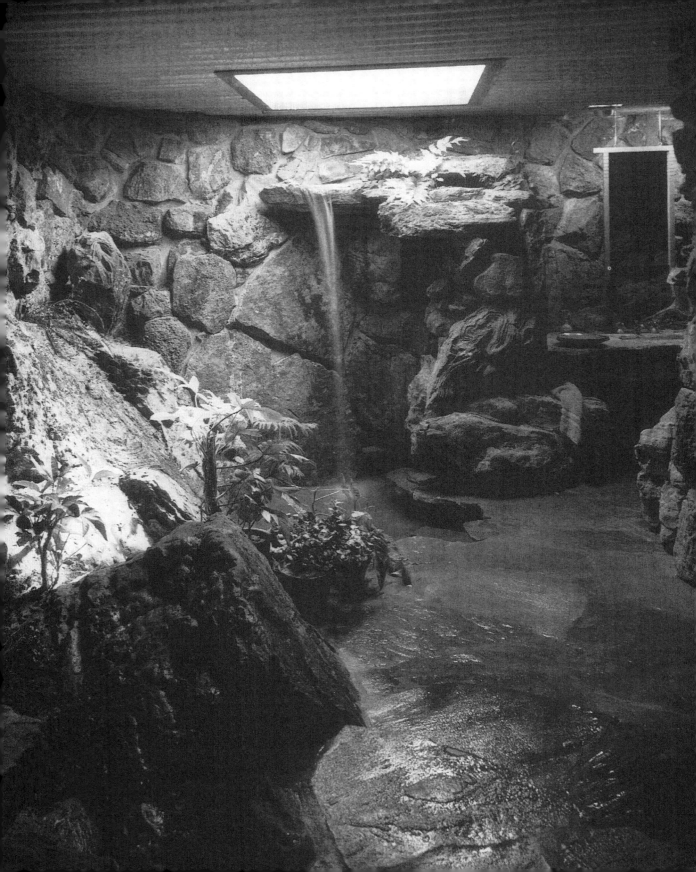

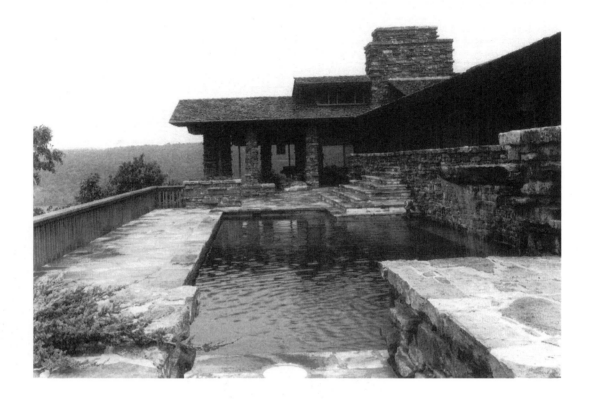

Raheen, Fayetteville vicinity, Arkansas.

© PAUL G. BESWICK/BESWICK INTERNATIONAL.

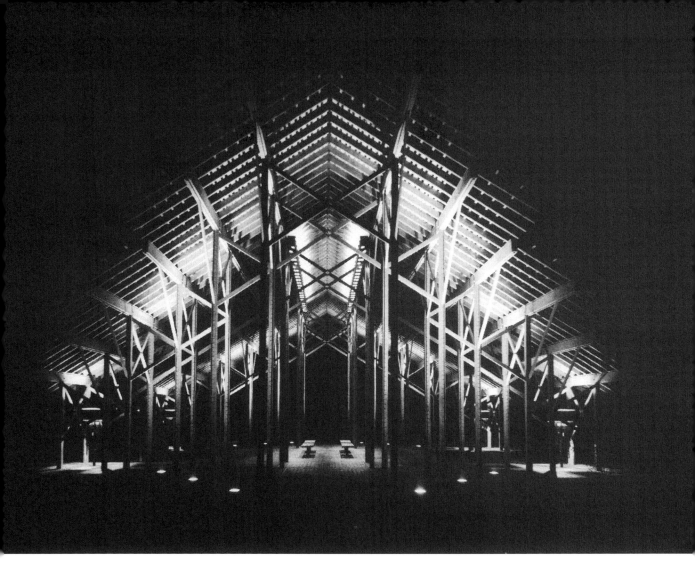

Pinecote Pavilion,
Picayune, Mississippi.
© TIMOTHY HURSLEY.

"If what we build, our interventions in the natural situation, aligns itself with the attributes of nature, perhaps it can in some didactic or other contributing way—as model, as symbol—inspire the inhabitants to align themselves in a more beneficial and meaningful way with the natural forces, the natural conditions, the natural rhythms of life. Surely there are benefits to be derived from living close to, and in harmony with nature."

Private residence,
Northwest Arkansas.
© TIMOTHY HURSLEY.

"First, it's talking with the client. . . ."

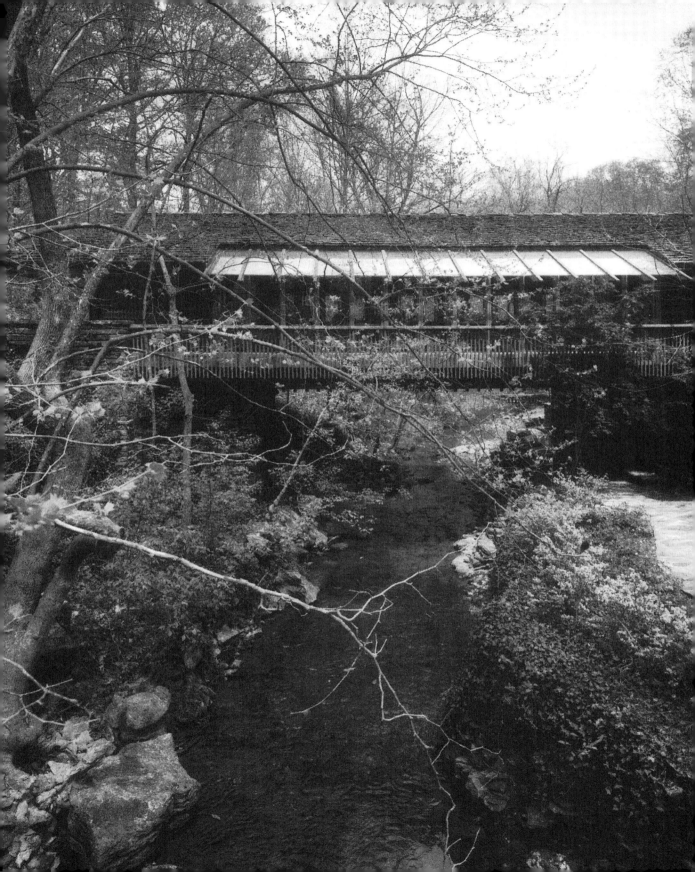

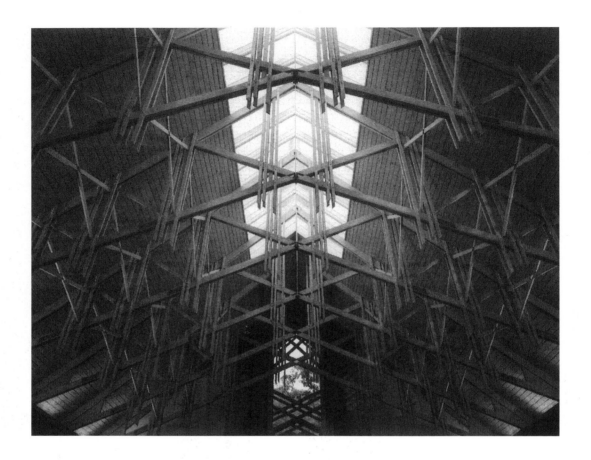

Thorncrown Chapel Worship Center, Eureka Springs, Arkansas.

© TIMOTHY HURSLEY.

"*Someone should try to build to meet the circumstances of his own time and place and take advantage of technology, but I don't think that architecture depends on everything being cutting-edge technology. We don't have to throw out traditional materials or structural systems just because we acquire new materials and techniques.*"

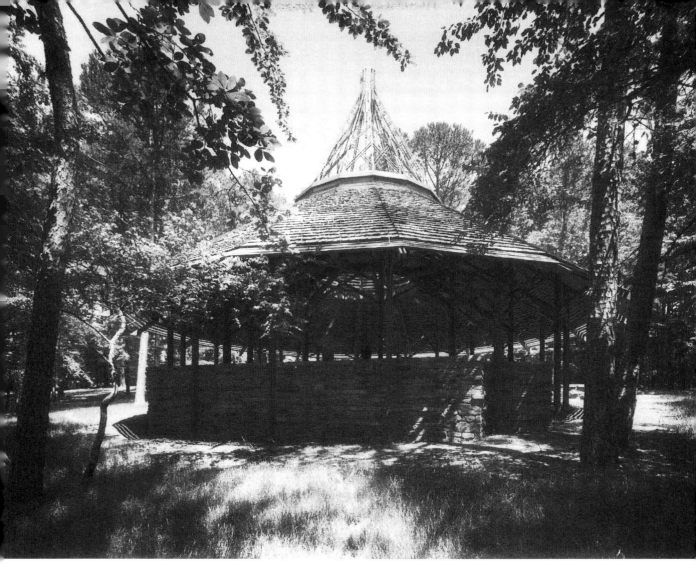

Verna Garvan Pavilion, Garvan Woodland Gardens, Hot Springs, Arkansas.

© TIMOTHY HURSLEY.

Pinecote Pavilion dock,
Picayune, Mississippi.
© TIM HURSLEY.

"First, it's talking with the client...."

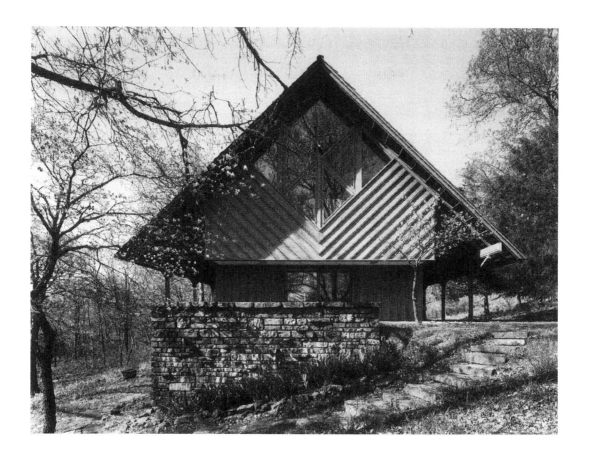

"He [Wright] had several principles, one of which was this idea of "simplicity." It had puzzled me for many years, . . . I couldn't quite see why he was preaching simplicity while designing buildings that had complex forms and complex spaces. I was equating simplicity with plainness. It became clear that the idea was more involved, multidimensional. I think there's a difference between something that is complicated and something that is complex; there's a difference between simplicity and plainness."

Reed residence,
Hogeye, Arkansas.

© TIM HURSLEY.

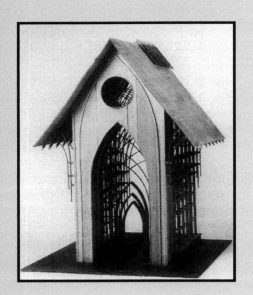

Model for Mildred B. Cooper Memorial Chapel, Bella Vista, Arkansas. Fay Jones + Maurice Jennings Architects.

PHOTO BY JIM BAILEY/YB PHOTOGRAPHY STUDIO.

"You should feel the relationship, to the parts and to the whole."

"Organic architecture has a central generating idea; as in most organisms every part and every piece has a relationship. Each should benefit the other; there should be a family of form, and pattern. You should feel the relationship to the parts and to the whole."

Mildred B. Cooper Memorial Chapel, Bella Vista, Arkansas.

© TIMOTHY HURSLEY.

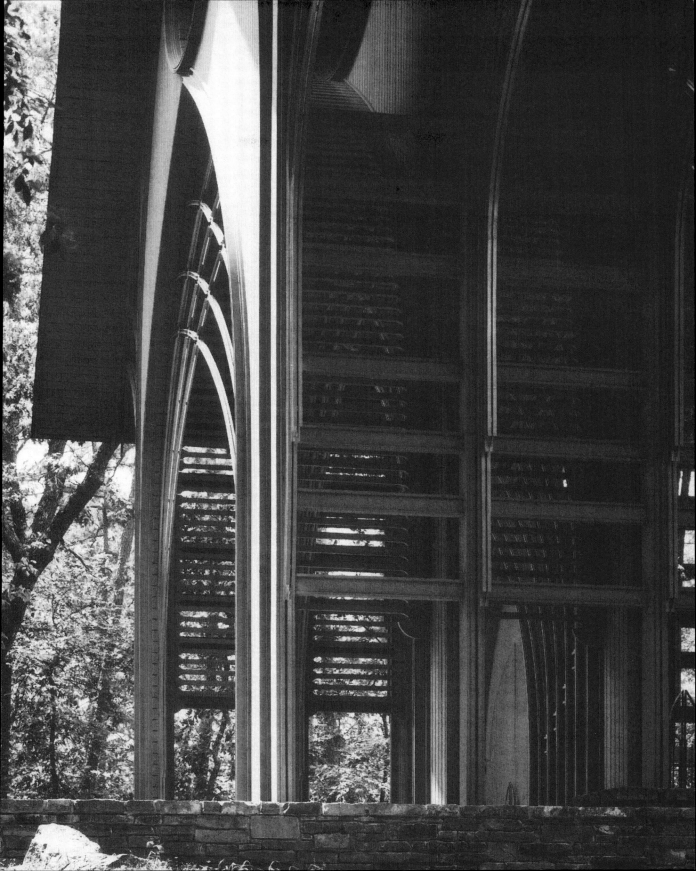

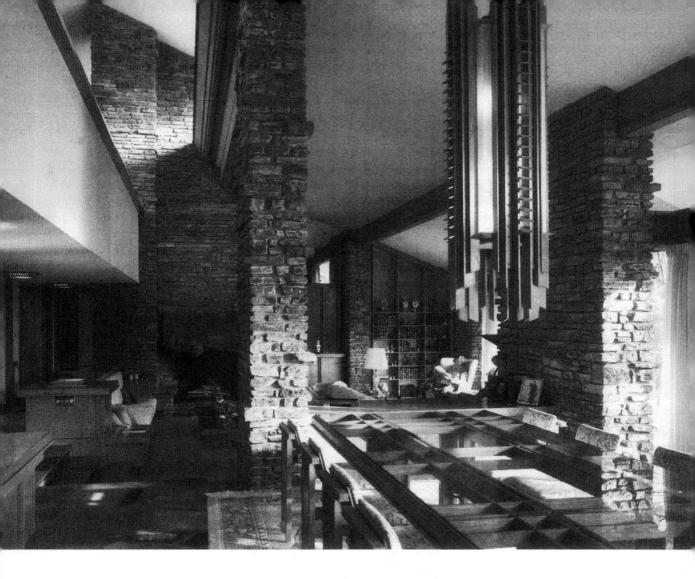

ABOVE, Watson residence,
Fairfield Bay, Arkansas.

© TIMOTHY HURSLEY.

RIGHT, Original drawings by Fay Jones of chairs for Thorncrown Chapel.

COURTESY OF SPECIAL COLLECTIONS DIVISION, UNIVERSITY OF ARKANSAS LIBRARIES, FAYETTEVILLE. PHOTO BY JIM BAILEY/YB PHOTOGRAPHY STUDIO.

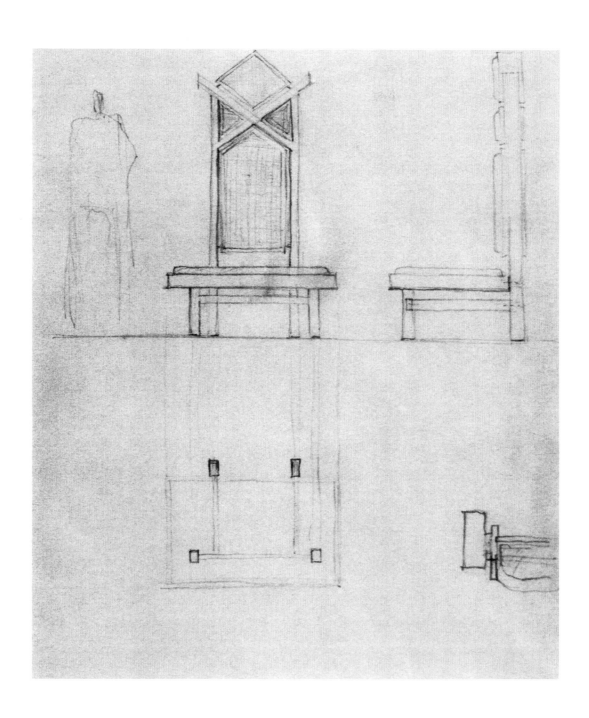

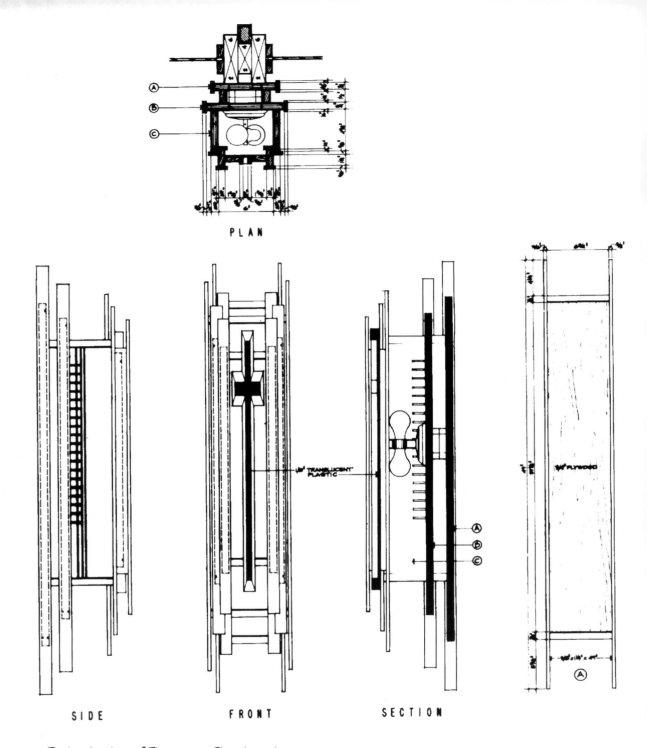

Design drawings of Thorncrown Chapel wood components.
COURTESY OF SPECIAL COLLECTIONS DIVISION, UNIVERSITY OF ARKANSAS LIBRARIES, FAYETTEVILLE.

"You should feel the relationship."

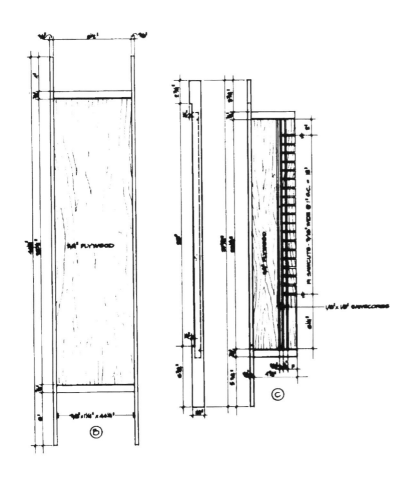

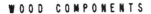

WOOD COMPONENTS

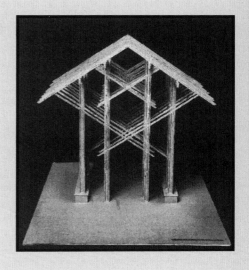

Model for Thorncrown Chapel, Eureka Springs, Arkansas. Fay Jones and Associates.

PHOTO BY JIM BAILEY/YB PHOTOGRAPHY STUDIO.

"You should feel the relationship."

Custom trim for recessed ceiling fixture. Fay Jones and Associates.

PHOTO BY JIM BAILEY/YB PHOTOGRAPHY STUDIO.]

Light fixture trim. Fay Jones and Associates.

PHOTO BY JIM BAILEY/YB PHOTOGRAPHY STUDIO.

"The generating idea establishes the central characteristics, or the essence, or the nucleus, or the core; it's the seed idea that grows and generates the complete design, where it manifests itself from the large elements down to the small subdivision of the details."

Snow residence, Fayetteville, Arkansas.

EZRA STOLLER © ESTO.

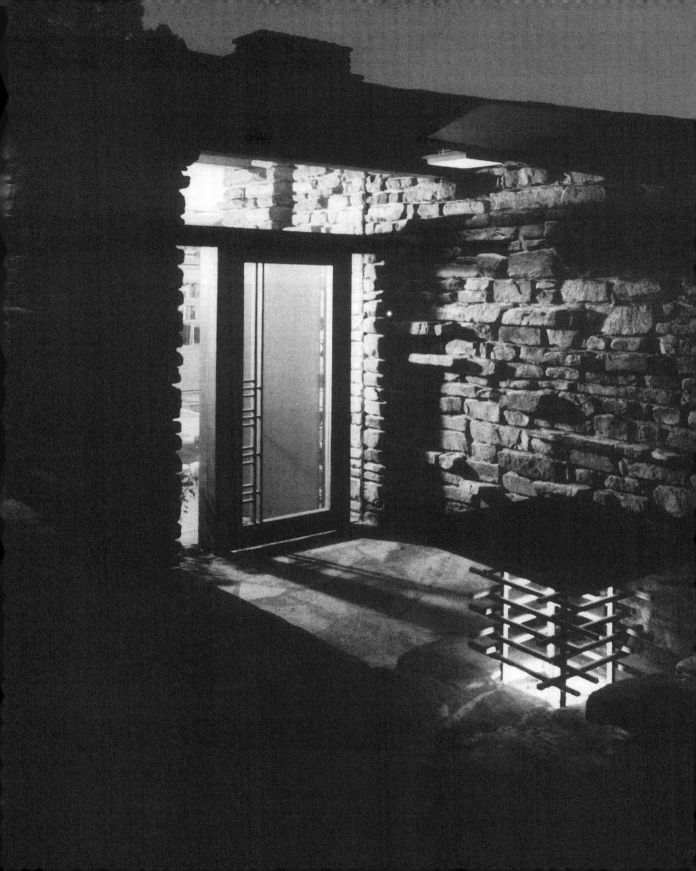

Light grate, John Begley Chapel, Columbia, Kentucky. Fay Jones + Maurice Jennings Architects.

PHOTO BY JIM BAILEY/YB PHOTOGRAPHY STUDIO.

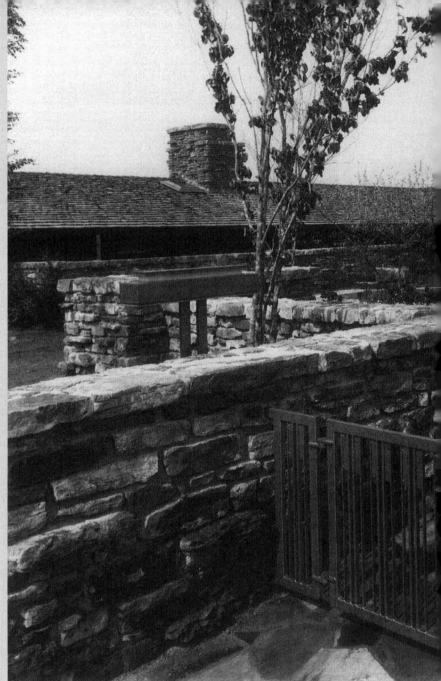

"You should feel the relationship."

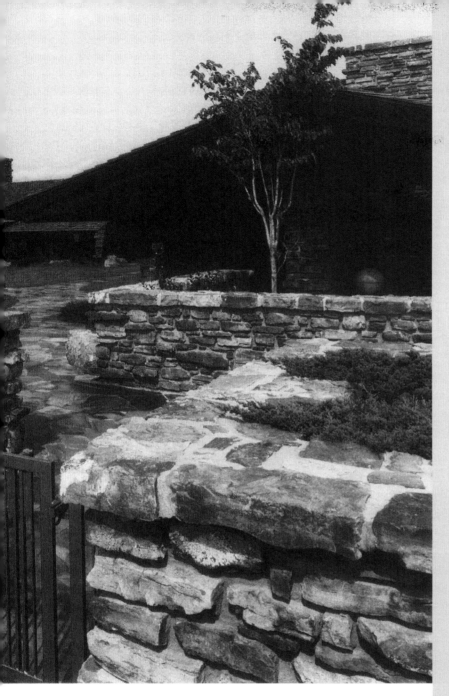

Fireplace poker. Fay Jones and Associates.

PHOTO BY JIM BAILEY/YB PHOTOGRAPHY STUDIO.

Raheen, Fayetteville vicinity, Arkansas.

© PAUL G. BESWICK/BESWICK INTERNATIONAL.

Mock-up of entry door jamb, Marjorie Allen Chapel, Powell Gardens, near Kansas City, Missouri. Fay Jones + Maurice Jennings Architects.

PHOTO BY JIM BAILEY/YB PHOTOGRAPHY STUDIO.

"I've always felt that the details, no matter how small or seemingly insignificant, are more than just nice things to notice. They are manifestation and expression, a kind of measure of the intensity of caring. And for all architects, caring should be a moral imperative."

Metal grate above recessed light fixture, Mildred B. Cooper Memorial Chapel, Bella Vista, Arkansas.

© TIMOTHY HURSLEY.

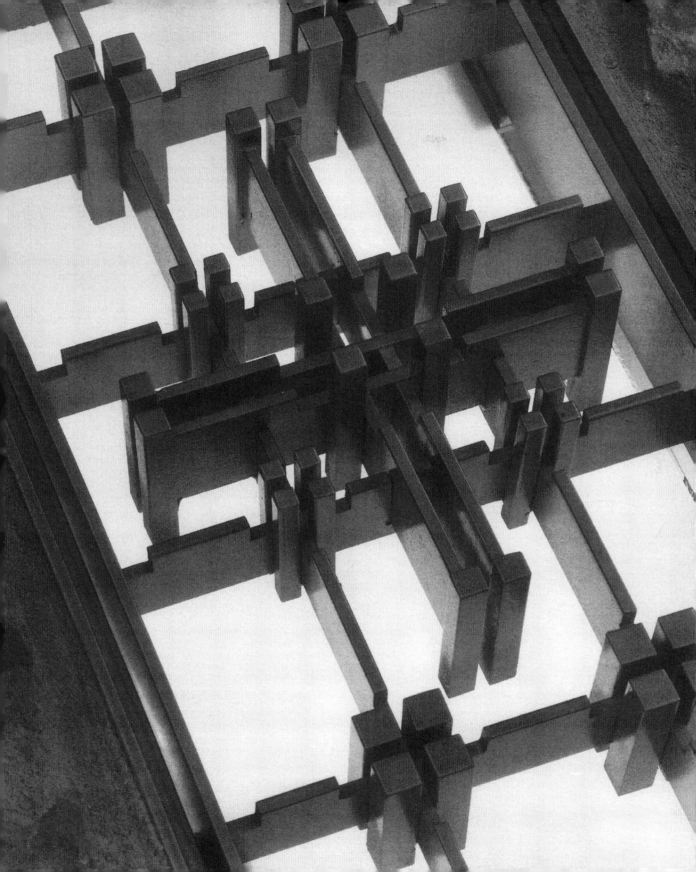

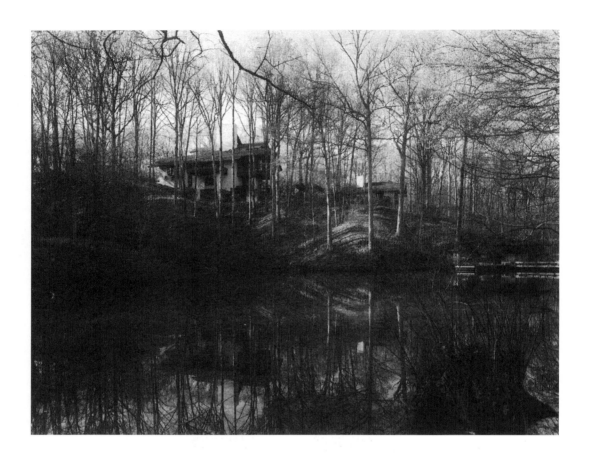

ABOVE, Edmondson residence, Forrest City, Arkansas.

© TIMOTHY HURSLEY.

"At final resolution, site and building should achieve a kind of singularity, or oneness, or harmonious and ideal relationship. You'd like to have it appear that man and nature planned and carefully arranged everything by mutual agreement, and then, that each benefited immeasurably from the other."

RIGHT, Pine Knoll, Little Rock, Arkansas.

EZRA STOLLER © ESTO.

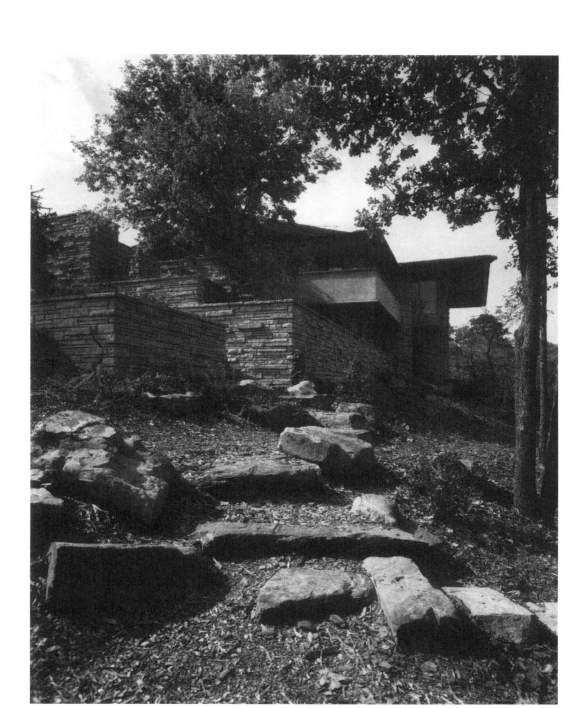

BELOW, Reed residence,
Hogeye, Arkansas.
© TIMOTHY HURSLEY.

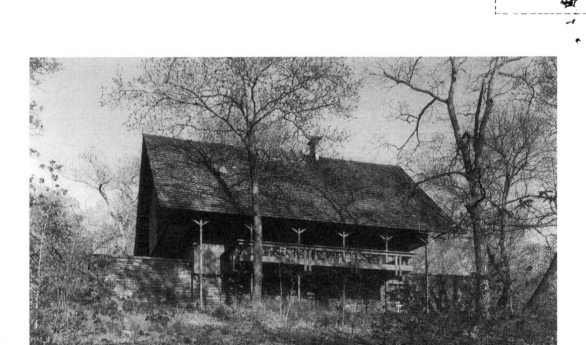

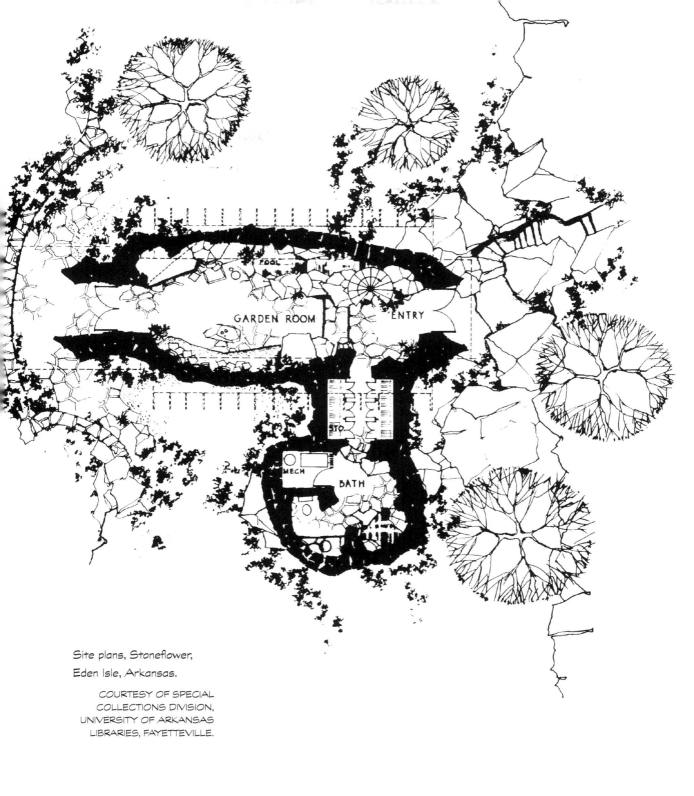

Site plans, Stoneflower, Eden Isle, Arkansas.

COURTESY OF SPECIAL COLLECTIONS DIVISION, UNIVERSITY OF ARKANSAS LIBRARIES, FAYETTEVILLE.

PINE KNOLL

HOUSE FOR MR. AND

Pine Knoll, Little Rock, Arkansas.
COURTESY OF SPECIAL COLLECTIONS DIVISION,
UNIVERSITY OF ARKANSAS LIBRARIES, FAYETTEVILLE.

ARCHITE

S. GRAHAM HALL

EUINE FAY JONES
GINOCCHIO CROMWELL and ASSOCIATE

"I have often been referred to as a regionalist, and I am not disturbed by that term because I think that any organic architecture is going to have this sense of belonging to the place where it is, seeming to grow out of the environmental context, responsive to particular places."

———————————

Raheen, Fayetteville vicinity, Arkansas.

© PAUL G. BESWICK/BESWICK INTERNATIONAL.

"You should feel the relationship."

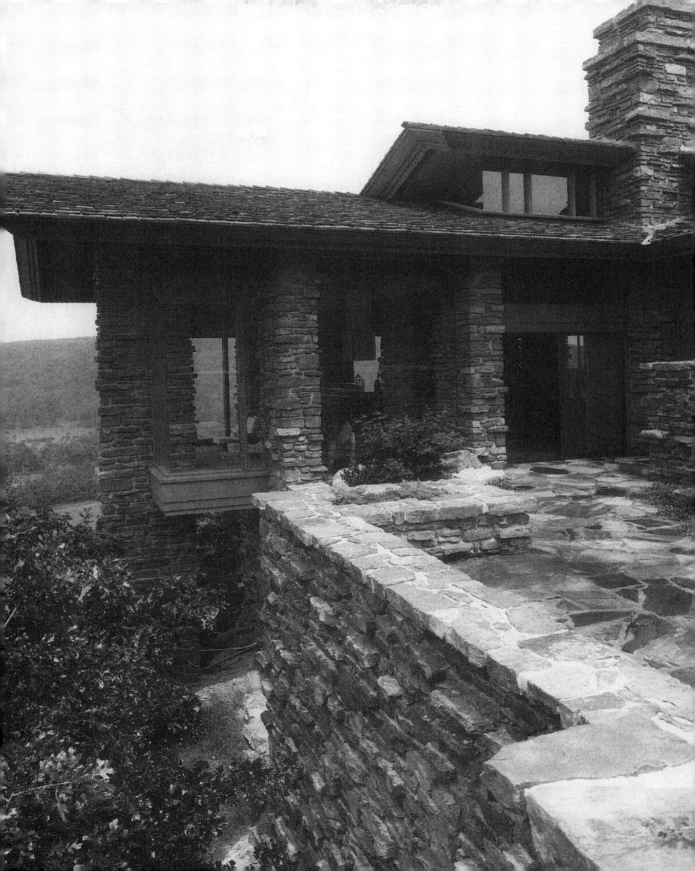

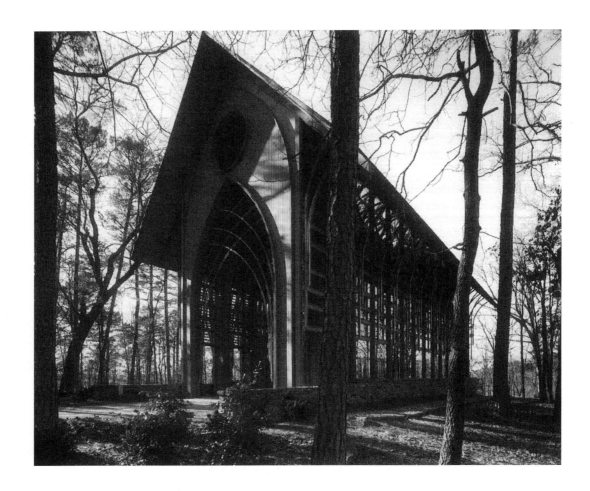

Mildred B. Cooper
Memorial Chapel,
Bella Vista, Arkansas.
© TIMOTHY HURSLEY.

Reed residence, Hogeye, Arkansas.
COURTESY OF SPECIAL COLLECTIONS
DIVISION, UNIVERSITY OF ARKANSAS
LIBRARIES, FAYETTEVILLE.

SOUTH ELEVATION

WEST ELEVATION

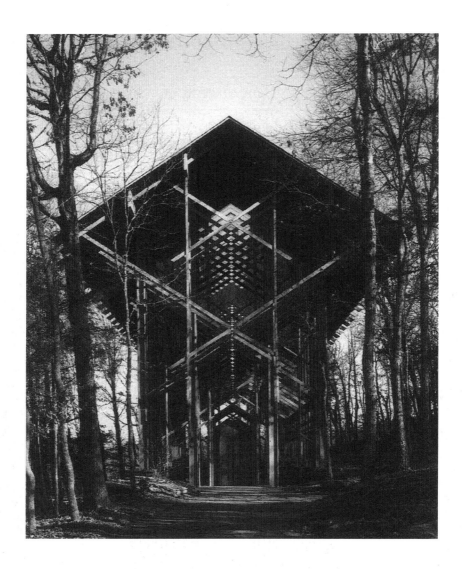

ABOVE, Thorncrown Chapel, Eureka Springs, Arkansas.

© TIMOTHY HURSLEY.

RIGHT, Double exposure print of interior of Thorncrown Chapel, Eureka Springs, Arkansas.

© TIMOTHY HURSLEY.

"There are a lot of these transitional areas where you're trying to string out these inside-out relationships in a horizontal way. In these areas, there can be no typical openings; there must be an extension of ceiling materials from inside to outside, and stone floor materials going from inside to outside without interruption."

"You should feel the relationship."

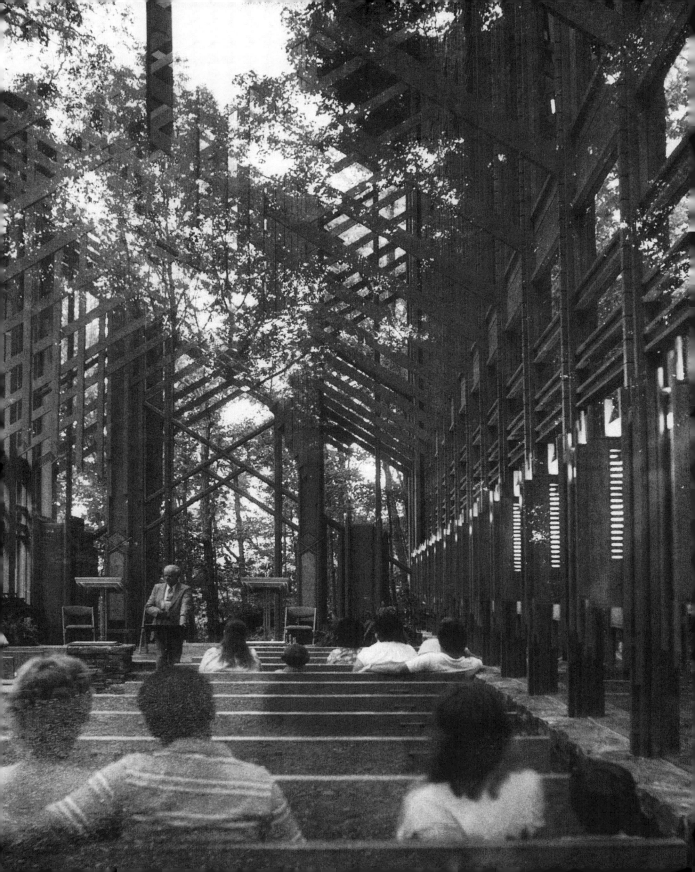

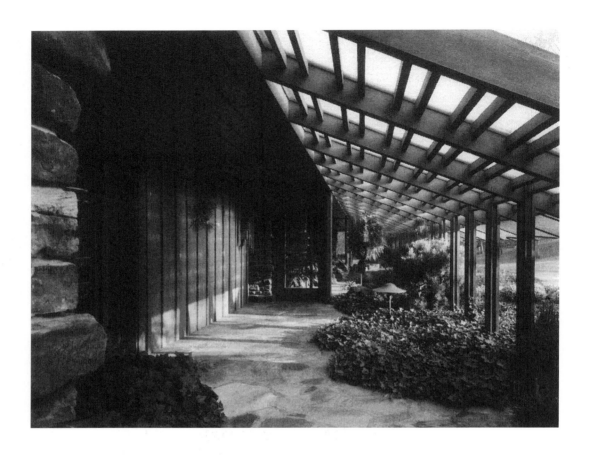

Private residence,
Northwest Arkansas.
© TIMOTHY HURSLEY

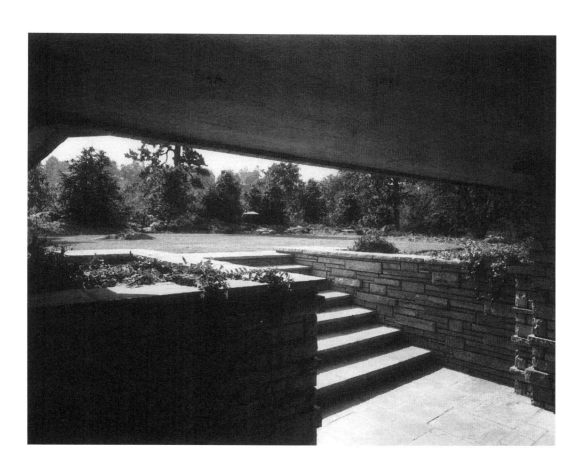

Pine Knoll, Little Rock, Arkansas.

EZRA STOLLER © ESTO.

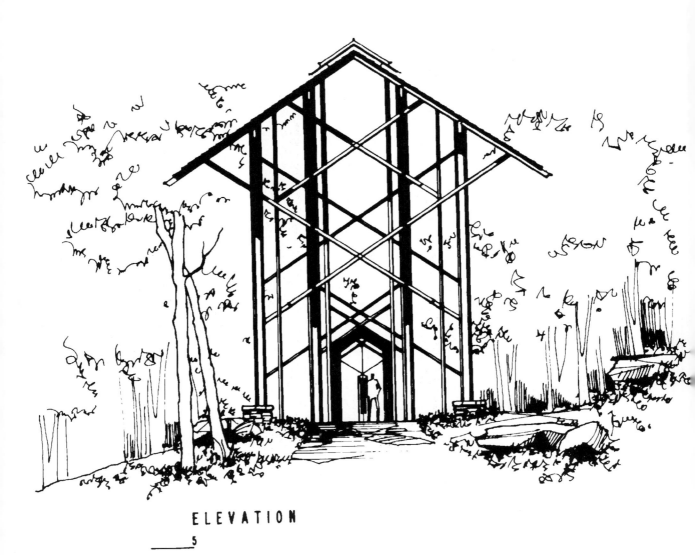

Design drawings, Thorncrown Chapel, Eureka Springs, Arkansas.

COURTESY OF SPECIAL COLLECTIONS DIVISION, UNIVERSITY OF ARKANSAS LIBRARIES, FAYETTEVILLE.

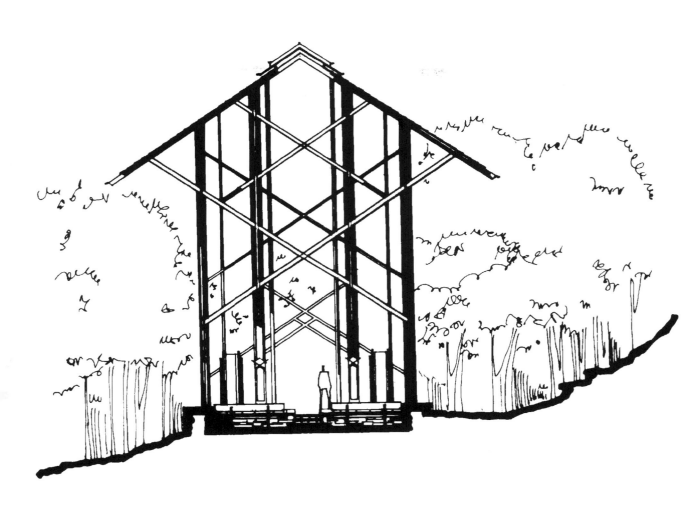

SECTION

5

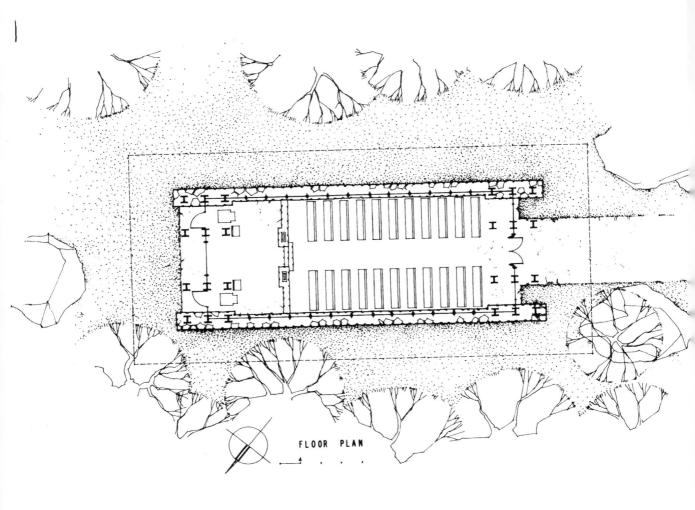

Design drawings, Thorncrown Chapel, Eureka Springs, Arkansas.

COURTESY OF SPECIAL COLLECTIONS DIVISION, UNIVERSITY OF ARKANSAS LIBRARIES, FAYETTEVILLE.

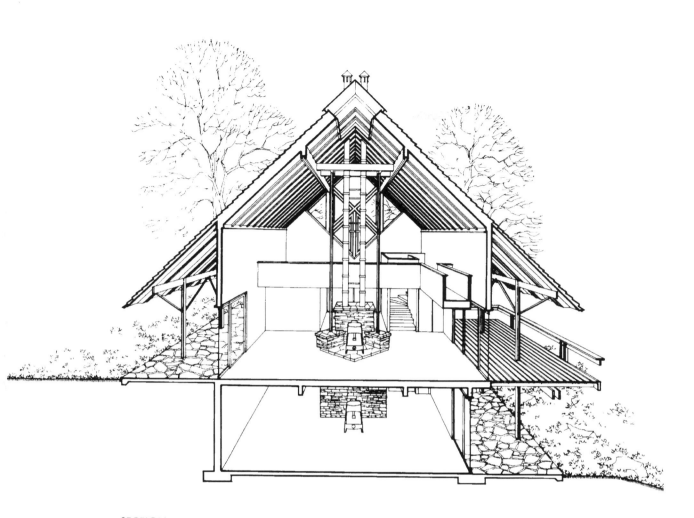

SECTION / PERSPECTIVE

Reed residence,
Hogeye, Arkansas.

COURTESY OF SPECIAL
COLLECTIONS DIVISION,
UNIVERSITY OF ARKANSAS
LIBRARIES, FAYETTEVILLE.

"You should feel the relationship."

Section of metal "rafter" from Verna Garvan Pavilion, Garvan Woodland Gardens, Hot Springs, Arkansas. Fay Jones + Maurice Jennings Architects.

PHOTO BY JIM BAILEY/YB PHOTOGRAPHY STUDIO.

"The nature of materials is a very fundamental principle of organic architecture. . . . Materials should be used in a way that conveys their strength and best qualities, letting each material—whether it is wood, stone, or steel—express its basic nature."

Mildred B. Cooper Memorial Chapel, Bella Vista, Arkansas.

© TIMOTHY HURSLEY.

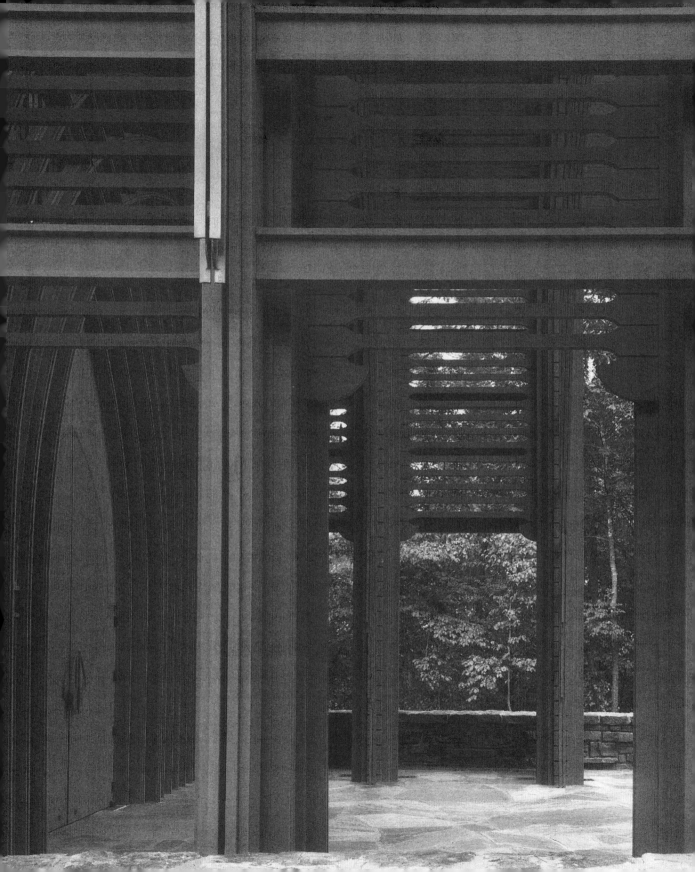

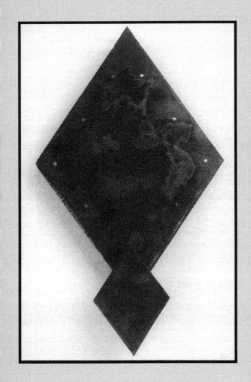

Ridge gusset, Marjorie Allen Chapel/Powell Gardens, near Kansas City, Missouri. Fay Jones + Maurice Jennings Architects.

PHOTO BY JIM BAILEY/YB PHOTOGRAPHY STUDIO.

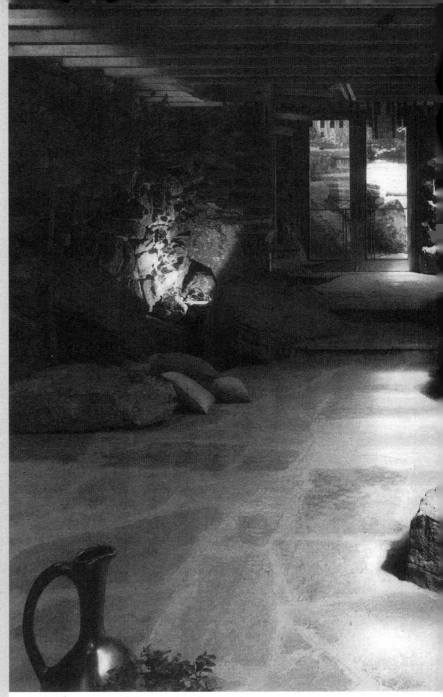

Stoneflower, Eden Isle, Arkansas.

© BALTHAZAR KORAB LTD.

"You should feel the relationship."

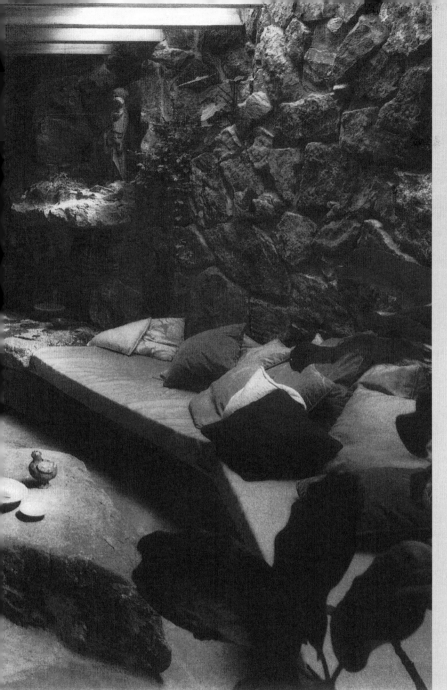

Rafter terminal, Sky Rose Chapel, Rose Hill Memorial Park, Whittier, California. Fay Jones + Maurice Jennings Architects.

PHOTO BY JIM BAILEY/YB PHOTOGRAPHY STUDIO.

"You should feel the relationship."

Appendix

As part of the project resulting in *"Outside the Pale": The Architecture of Fay Jones* exhibit, the Arkansas Historic Preservation Program, an agency of the Department of Arkansas Heritage, undertook an extensive survey of Jones-designed buildings in Arkansas. Seven of those were deemed to be the most significant examples of his work and were nominated to the National Register of Historic Places, the country's official list of historic properties deserving preservation.

The Jones Residence
Fayetteville, Washington County
Date Completed: 1956

As the earliest constructed design by Fay Jones, the two-bedroom, two-story house was built in a new subdivision on the north end of town for Jones's family, consisting of his wife Gus and two young daughters. The Jones residence contains many of the characteristics which continue to play a significant role in all of his other designs. The house is rectangular in form with a simple gable roof, and the materials Jones utilized in construction are appropriate to the wooded site the house is placed on. Of wood-frame construction, the Jones residence is sheathed in board-and-batten redwood siding and features fieldstone foundation walls and piers on the lower level. The entrance to the site is indicated by a tall, lighted entry sculpture of Jones's design. The house is set back from this entrance with curvilinear stone walls denoting the visitor's path to the single entrance to the house, located on the east side of the property, opposite the street. The interior features

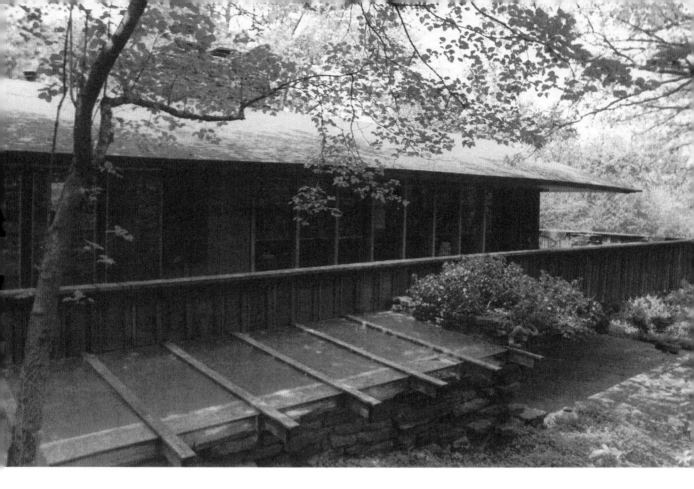

PHOTOGRAPH COURTESY OF ARKANSAS HISTORIC PRESERVATION PROGRAM.

built-in seating and bookshelves, and all other furniture and built-in lighting in the house was designed by the architect. Flagstone flooring covers the lower living areas, which include a study, bathroom, and bedroom. One interesting feature on this lower level is a large boulder which was unearthed during the excavation for the house and left to form one wall of the study, now covered with maidenhair fern. The open plan of the building centers around a massive fieldstone chimney that serves as both a structural and a decorative element. The Jones residence received its highest praise when architect Frank Lloyd Wright visited the house in the 1950s and praised it as an excellent example of organic architecture.

Thorncrown Chapel
Eureka Springs, Carroll County
Date Completed: 1980

Thorncrown Chapel is Jones's most recognized and, arguably, his most respected work. An expression in glass and wood, Thorncrown Chapel was constructed out of southern-pine two-by-four lumber. Jones also used two-by-sixes, two-by-twelves, and large sheets of glass. In order to ensure minimal disturbance of the wooded site, Jones decided that "no structural member, for example, could be larger than two men could carry through the woods." With this in mind, the trusses were assembled on site. The constraints that the site presented directly influenced the evolution of the simplicity of the structure. Upon approaching the gray-stained wood chapel from the southwest, winding along a tree-lined path, one notices the high, vertical nature of the chapel, which rises forty-eight feet. The chapel is rectangular in form, only twenty-four feet wide and sixty feet long. The verticality of the structure is emphasized by the diamond-shaped void between the hollow metal joints. The repetitive pattern leads the eye upward and further in, creating a play of pattern and light. Thorncrown Chapel was awarded the AIA Honor Award in 1981, and this recognition led, in part, to Jones's presentation with the AIA Gold Medal in 1990.

PHOTOGRAPH COURTESY OF ARKANSAS HISTORIC PRESERVATION PROGRAM.

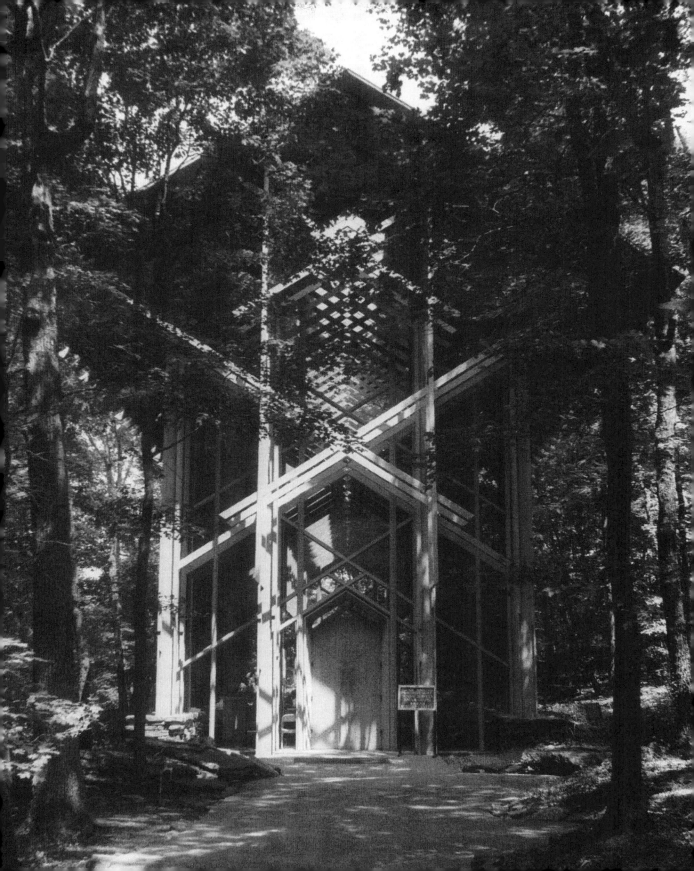

Shaheen-Goodfellow Weekend Cottage,
Stoneflower
Eden Isle, Cleburne County
Date Completed: 1965

This house was Jones's inspiration for the design of Thorncrown Chapel in Eureka Springs. The house is a two-story rectangular structure with a projecting deck that overlooks Greers Ferry Lake. Designed for two young landscape architects, Bob Shaheen and Pat Goodfellow, Stoneflower was a modest commission with a nominal budget of twenty-five thousand dollars. Built on a rock foundation, the house is rectangular in form and features a wood-frame construction. Exactly one-half the size of Thorncrown Chapel, Stoneflower is twelve feet wide, twenty-four feet high, and thirty feet long. A deck, which is also thirty feet in length, projects off of one end of the house, forming a long, rectangular shape. The structure is faced with board-and-batten redwood siding and fenestrated with large windows on either gable end. Interior fitted screen doors allow the glass windows to be opened for ventilation. The sides of the house are without windows except for a band in the eaves which open to allow the circulation of air throughout the building. The lower level within the stone foundation wall is lit by a band of fiberglass panels, which form a skylight over the projecting stone.

PHOTOGRAPH COURTESY
OF ARKANSAS HISTORIC
PRESERVATION PROGRAM.

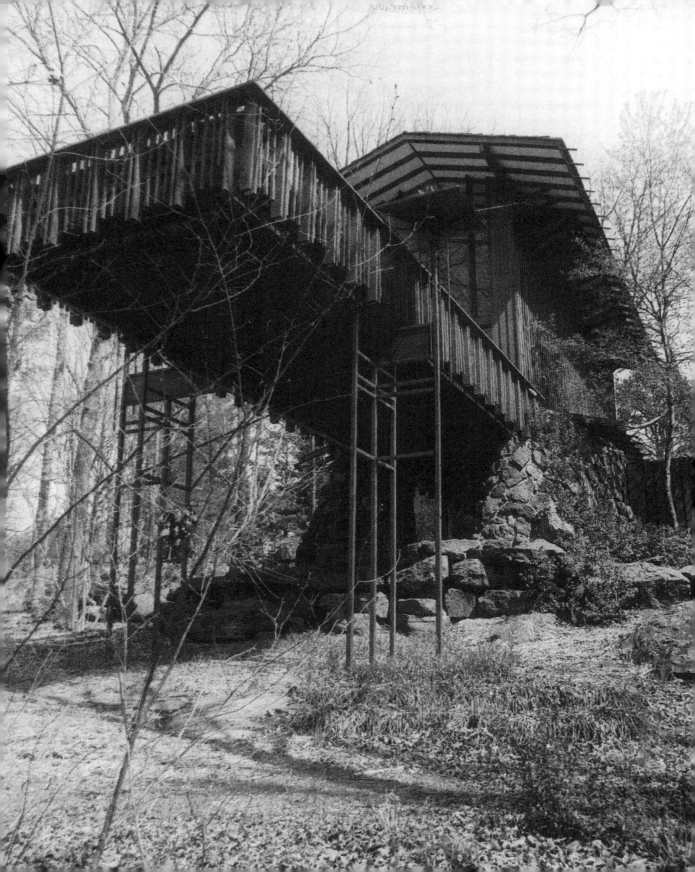

Applegate Residence
Bentonville, Benton County
Date Completed: 1967

The Applegate residence is an entirely curvilinear building which is highly unusual in both elevation and plan. The house, approximately nine thousand square feet in size, features curving walls, constructed entirely of Ozark stone, which are over twenty inches thick in some areas. The house features a flat roof with sixteen domed skylights, and the wide projecting eaves have a raised abstract design at the cornice. Sited on a hill overlooking a three-acre lake, the residence sits on fourteen acres of property. The visitor approaches the house via a curving drive up a hill to the north of the house, and the primary entrance is located next to the circular drive on the west. The Applegate residence is built on the slope of a hill, and the east side of the house is three levels in height and punctuated by triangular balconies with iron balustrades and large sliding-glass doors and banks of fixed windows. Other windows include small circular bathroom windows, which Jones salvaged from two 1957 Chevys because of their perfect curve and thickness. The interior contains a large indoor pool, which is sited in a central two-story atrium area. As the house was built by the Applegates for entertaining, there are very few interior doors and only two bedrooms, which creates a very open plan. The three circular showers in the house feature projecting rock "waterfalls" instead of shower heads. Mechanical features include the Jones-designed heating and air conditioning returns, which are designed into the stonework. Jones also utilized this system at Thorncrown Chapel. Typical of other houses designed by the architect, all cabinetry in the house was hand-built to Jones's design specifications.

PHOTOGRAPH COURTESY OF ARKANSAS HISTORIC PRESERVATION PROGRAM.

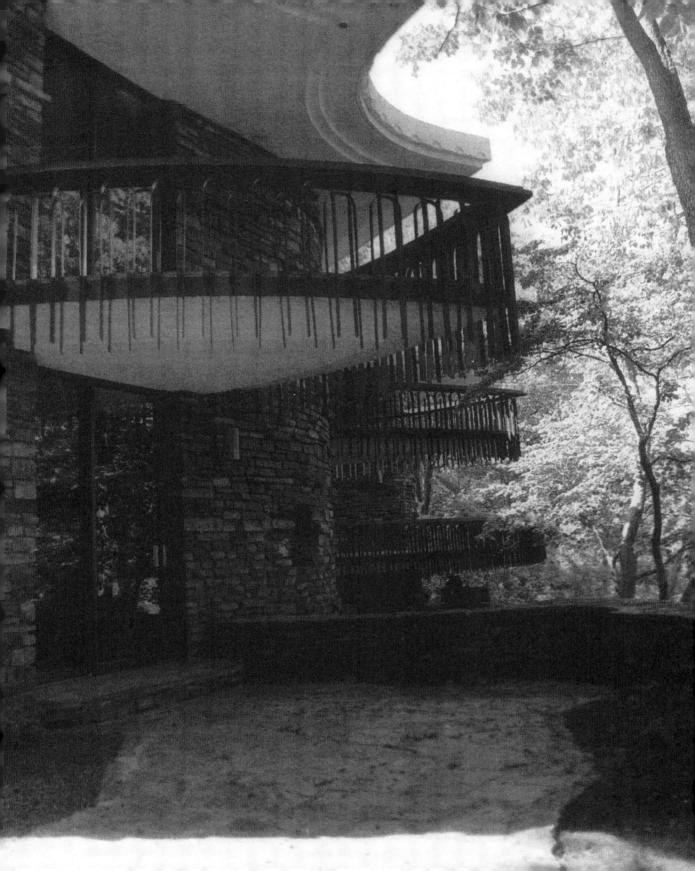

Edmondson Residence
Forrest City, St. Francis County
Date Completed:
 Main Residence, 1976
 Guesthouse, 1982
 Terrace and Greenhouse, Boathouse, 1985

Commissioned by Don and Ellen Edmondson, the Edmondson residence represents Fay Jones's most completely organic work. He designed the main house, a guesthouse and a boathouse as well as the majority of the furnishings for the buildings. He also designed an extensive number of exterior items which include a mailbox, entrance gates, entrance light, a fountain, ground lighting, and sculptural works. The roofs of the residences are covered in red tile and cream colored stucco sheathes the walls, both of which make the house unique among Jones's designs. The massing of the main house is extremely irregular, with a projecting deck on the northeast side and a projecting screened-in porch on the northwest side overlooking the trellis and guesthouse area. The house is four stories tall, with stationary single-light windows and doors to light the interior. The southwest elevation is particularly fortress-like, as it rises above the steep hill on which the house is sited, and the windows are high and impenetrable. The level of detail on this house is extraordinary, with the plans for the main house being more than one hundred pages in length. Descending along the red-brick pavers from the main house to the guesthouse to the northwest, the visitor walks under a large trellis which Jones designed to divide the patio area and to shelter those in the Jacuzzi from the eyes of those above them in the main house. The guesthouse, constructed a few years after the main house, is finished in exactly the same manner as the main house. The property also contains a sixteen-acre lake near which Jones designed a small square, pagoda-like boathouse out of wood.

PHOTOGRAPH COURTESY OF ARKANSAS HISTORIC PRESERVATION PROGRAM.

Reed Residence
Hogeye, Washington County
Date Completed: 1980

The Reed residence is a two-and-one-half-story wood-frame building. The cedar shake roof is steeply pitched with a band of skylights on the ridge and wide overhanging eaves with exposed rafter ends. Sheathed in red-cedar siding, the simple, rectangular house consists of a basement, a kitchen and living area on the first level, and two bedrooms connected via a catwalk on the upper level under the eaves. This open plan is heated with a wood stove, and the house is cooled utilizing the breezes which flow through the large polygonal windows at the east and west gable ends. The entire house rests on a fieldstone and concrete foundation. This house is said to be the most vernacular of Jones's designs, as the design was modeled on the barns of the rural areas of the state.

PHOTOGRAPH COURTESY OF ARKANSAS HISTORIC PRESERVATION PROGRAM.

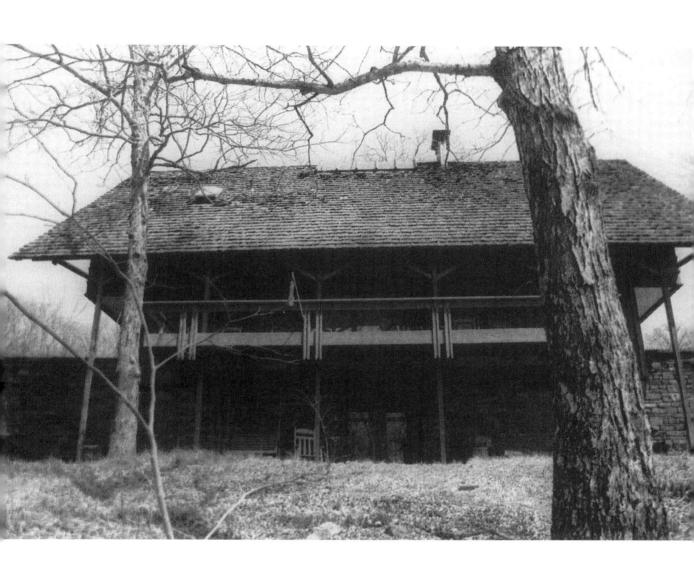

Mildred B. Cooper Memorial Chapel
Bella Vista, Benton County
Date Completed: 1988.

Located on a hill in Bella Vista, Cooper Chapel was constructed in honor of Mildred B. Cooper. The design was commissioned by the children of Mr. and Mrs. John Cooper Sr.

Built of redwood, stone, and steel, the Mildred B. Cooper Memorial Chapel evolved from a simple palette of materials which are expressed in a rich and dynamic way. As one approaches the chapel, the repetitive pattern formed by the steel framework invites the visitor in. Like Thorncrown, Cooper Chapel is rectangular in plan with a steeply pitched gable roof and an infrastructure distinguished by "laced" cross-bracing. Yet, unlike Thorncrown Chapel, Cooper Chapel utilizes the structural and expressive qualities of steel. The main façade of the chapel is dominated by a large redwood Gothic arch with a rose window. This arch is set slightly in front of the entrance under the roof and forms a vestibule which is paved in flagstone. The pointed profile of the arch is repeated in the shape of the double-leaf entry, and most noticeably in the curvilinear steel cross-bracing which continues the entire length of the chapel, forming an elaborate visual pattern. When one views either side of the chapel, the strength of the structure becomes more noticeable. Tall wood columns, six feet apart, rest on fieldstone walls. Paired metal brackets are attached to the exterior of the columns and curve out to support the wide overhang of the roof above. These brackets mirror the steel I-beams of the interior which curve and interlock and which are painted a bronze color to match the stain on the wood.

PHOTOGRAPH COURTESY OF ARKANSAS HISTORIC PRESERVATION PROGRAM.

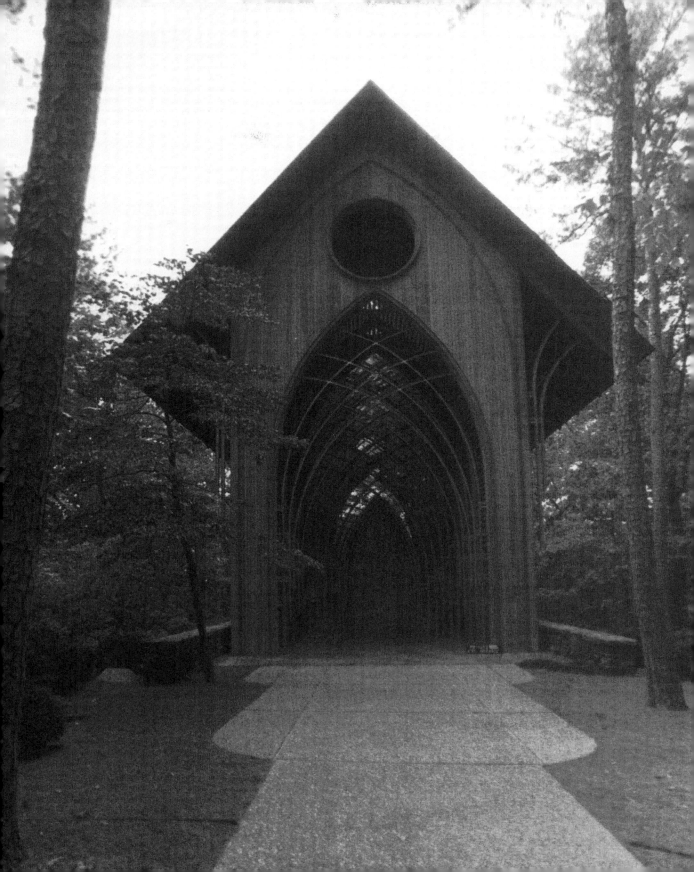